A POSTCARD
FROM THE
COTSWOLDS

Jan Dobrzynski

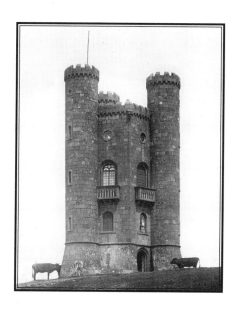

Title page: At 1,047ft above sea level, Broadway Tower offers one of the finest viewpoints of the Cotswolds.
(Percy Simms, Chipping Norton)

First published 2011

The History Press
The Mill, Brimscombe Port
Stroud, Gloucestershire, GL5 2QG
www.thehistorypress.co.uk

British Library Cataloguing in Publication Data.
A catalogue record for this book is available from the British Library.

ISBN 978 0 7524 5928 8

Typesetting and origination by The History Press
Printed in Great Britain

Contents

'Stretching from Broadway to Bath, and from Birdlip to Burford, and containing about three hundred square miles, is a vast tract of hill country, intersected by numerous narrow valleys. Probably at one period, this district was a rough, uncultivated moor. It is now cultivated for the most part, and grows excellent barley. The highest point of this extensive range is eleven hundred and thirty-four feet, but the average altitude would not exceed half that height. Almost every valley has its little brook. The district is essentially a "stone country" for all the houses and most of their roofs are built of the local limestone, which lies everywhere on these hills within a few inches of the surface.'

<div align="right">

(*A Cotswolds Village or Country Life and Pursuits in Gloucestershire*,
Joseph Arthur Gibbs, 1898)

</div>

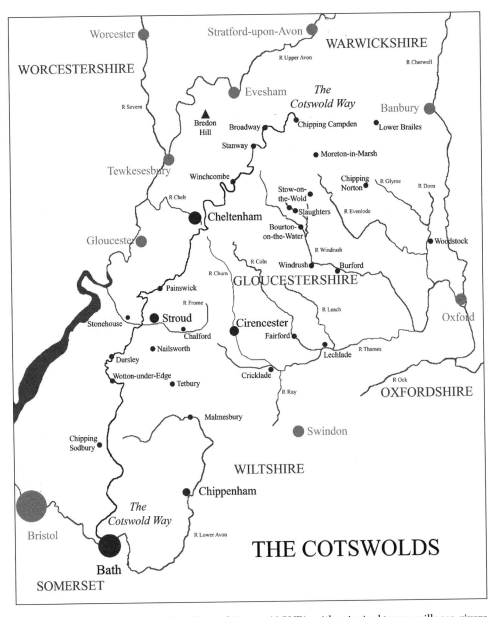

The Cotswolds, Area of Outstanding Natural Beauty (AONB), with principal towns, villages, rivers and the 104-mile-long Cotswold Way footpath.

Introduction

The region of hills, valleys, farmland and pastures collectively called the Cotswolds cannot fail to delight the eye of the visitor. An Oolitic limestone ridge and range of hills that stretches 90 miles north-east of Bath is the backbone to this upland countryside, reaching a maximum width of 30 miles at Painswick and Burford. The highest point of the range of hills is Cleeve Common near Cheltenham, which rises 1,080ft above sea level. The Cotswolds region lies principally in the county of Gloucestershire, bordered by Worcestershire in the north-west. To the north-east is the county of Warwickshire, the gateway to the Midlands, Birmingham and Stratford-upon-Avon; home and birthplace of William Shakespeare. The hills are watershed for rivers to the east and south, principally tributaries of the Thames and Lower Avon. From here the ground begins to slope more gently towards the lower lying bordering counties of Oxfordshire, Wiltshire and Somerset. In contrast, the steeper western escarpment of the Cotswold Edge feeds its tributaries more abruptly into the river Severn. From arable farming to natural countryside, picturesque, quiet villages nestled on slopes and sheltered in valleys, to busy cloth and wool towns bustling with tourists – the 790 square miles designated since 1966 as the Cotswolds Area of Outstanding Natural Beauty (AONB), rightfully lays claim to its title as the 'The Heart of England'.

As with many ancient place-names the origins of the name 'Cotswolds' (and when it was first used) is subject to conjecture, but it is generally accepted that the name is derived from the word 'Cot' meaning animal pen (sheep in this case) and 'Wolds' meaning rolling hills. Not surprisingly, farming and the rearing of sheep for wool and meat developed as the principal local industries on these rolling hillsides, with cloth weaving and heavier industries centred on the valleys around Stroud. Since the Stone Age, the transport of animals and goods for barter and trade gave rise to the transport infrastructure of the region. The tops of the Cotswold hills themselves became well-trodden ancient ridgeways, roads and tracks, and the main trade routes through the district have become a delight to modern-day walkers. The straight roads built during the Roman occupation were mainly centred on Cirencester (Corinium). Some of these roads incorporated existing ancient ridgeways to cross the Cotswold uplands. Akeman Street ran from Cirencester to Bath along part of the Fosse Way (the Fosse Way ran from the Humber Estuary to the Devonshire coast). The Salt Way from Droitwich crossed the Fosse Way and Icknield Street, which ran from Woodstock to Wotton-under-Edge. Ermin Street, formerly a British trackway, passed through Cirencester on its way to South Wales. A local route, the White Way, ran north from Cirencester to Roman villas at Chedworth and Withington. By the nineteenth century, an intricate network of improved turnpike roads had evolved to supplement the existing Roman and medieval routes that criss-crossed the Cotswolds. The turnpikes were the important stagecoach routes between Worcester, London, the Midlands, Black Country, Bristol, Bath, Gloucester and South Wales. During the later part of the nineteenth and the

early twentieth century, the old turnpike roads – in decline after the coming of the railways – saw in the age of the cyclist and pioneer motorist; new breeds of tourist keen to explore the Cotswold countryside by road. Today motorways serve the transport needs of the region with the M5 to the west, the M40 to the east, and the M4 that slices through the southern extremity of the Cotswolds north of the city of Bath.

Despite lying at a major transport crossroads for railways and roads, the Cotswolds region has preserved its distinct personality. The golden honey-coloured local stone and architectural styles make Cotswold buildings uniquely identifiable with the region. Similarly, coloured dry stone walls are also a notable feature of the countryside, as were once the sheep that roamed the hillsides – not so iconic today. The old breeds of Cotswold sheep, especially the Cotswold Lion – so named because of its woolly mane – was the basis of wool production and cloth manufacture in the district. The subsequent loss of wool production owing to competition from the north of England forced the whole of the Cotswolds into sustained economic decline. Ironically, the decline from the mid-eighteenth and early nineteenth centuries helped to preserve many of the buildings from that time, since it largely halted further building of factories, mills and the redevelopment and growth of towns. Despite this, Stroud's cloth mills continued to use the power of the Cotswolds' running water, and the town and the adjoining valleys changed greatly with the demands of the industrial revolution. By the beginning of the twentieth century, the Cotswold Lion sheep had become an endangered rare breed, but presently the species has enjoyed a reprieve, and a respectable number survive in a few flocks. However, their re-emergence as a feature of the Cotswolds is as unlikely as the revival of the wool industry they once served.

The charm of the Cotswold countryside has attracted tourism as well as wealthier residents willing to commute to London, Bristol and the Midlands. Equally, the larger towns on the edge of the Cotswolds, the spa town of Cheltenham with its Regency splendour and the famous venue for the Gold Cup, the main event of the annual Cheltenham Festival; Cirencester with its Roman connections, and the city of Bath have greatly contributed to the popularity of the region. Despite the pressures of tourism and suburban expansion, the Cotswolds have remained largely unspoilt and continue to attract visitors and prospective house owners alike, all of whom can celebrate in the knowledge that the region is one of the most beautiful and desirable locations in Britain.

> The 100-mile-long Cotswold Way traverses the western edge of the Cotswolds between Chipping Campden and Bath. Details of its course are referred to at the beginning of Chapters 1, 2, 4 & 6 and after the captions as appropriate (with mileages from the start at Chipping Campden).

The postcards included in this book are from the author's collection. Publication details are given at the end of the captions, along with posted up dates, if and as they appear on the cards.

1

The North Cotswolds

'About the middle of May the lovely, sweet-scenting lilac come into bloom. It brightens up the old, time-worn barns, and relieves the monotony of grey stone walls and mossy roofs in the Cotswolds village.'

(A Cotswolds Village or Country Life and Pursuits in Gloucestershire,
Joseph Arthur Gibbs, 1898)

The Cotswold Way begins at Chipping Campden Town Hall; it skirts the Worcestershire and Gloucestershire border over the north-western extent of the Cotswold Edge, on its way through Broadway to the cross at Stanton in Gloucestershire, at just under 10 miles from the start.

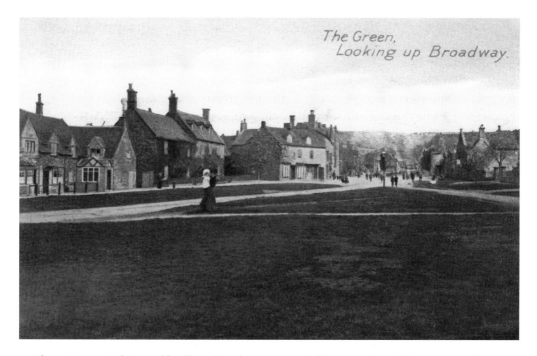

The Green,
Looking up Broadway.

The quintessential Cotswolds village, Broadway is typical of the many beautiful towns and villages that populate the district. It was shortly after the Norman Conquest that many similar market towns were founded in the Cotswolds, such as Burford, Chipping Campden, Moreton-in-Marsh, Northleach, Stow-on-the-Wold and Winchcombe. *(Publisher unidentified)*

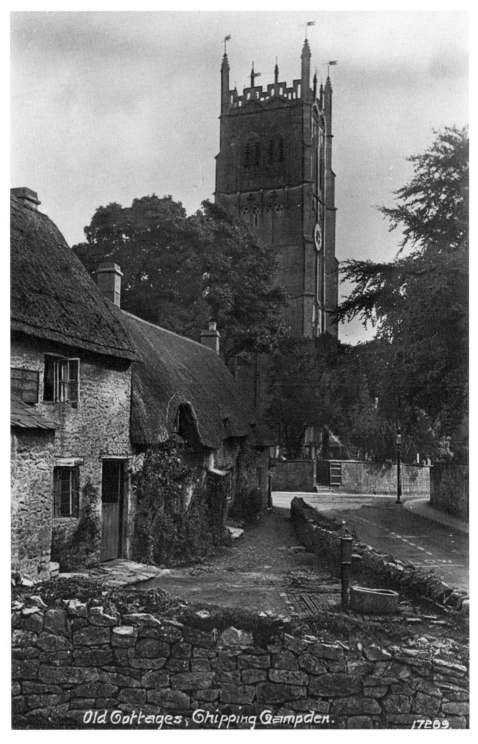

Old Cottages, Chipping Campden. 17289.

From the Middle Ages Chipping Campden grew as a prosperous wool town. Largely unspoilt, it has many prestigious buildings, including the early Perpendicular church of St James. The old cottages still stand at the corner of Cidermill Lane, which leads to the south entrance of Chipping Campden School. *(Green's of Broadway)*

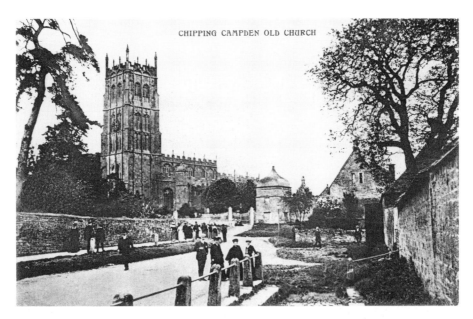

St James' Church from the junction of Station Road, on the right is the entrance to Banquette House pavilions and the grounds of the former Campden House commissioned by Sir Baptist Hicks (1551–1629), 1st Lord Campden, and one-time Lord Mayor of London. The newly built grand house was totally destroyed when deliberately set on fire to prevent its capture by Parliamnetary forces during the Civil War. *(Jacques Junr's Broadway)*

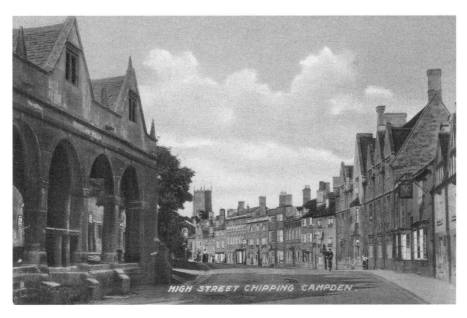

Chipping Campden – 'chipping' derived from the word 'ceping' which means market – developed as a prosperous wool market town. On the left in the town's High Street is the open arched Market Hall built by Sir Baptist Hicks in 1627. The Market Hall was used to sell produce and not, as commonly thought, wool. *(The 'Mercia' Series', F.C. Rickett, Claverdon, Warwick & Stratford-on-Avon)*

The door of St James' Church might be considered a suitable starting point for the Cotswold Way since the entrance at Bath Abbey marks the end of the 100-mile path. The official beginning or the end – dependent on which direction one walks – of the Cotswold Way is indicated with a stone marker at the corner of the Town Hall.

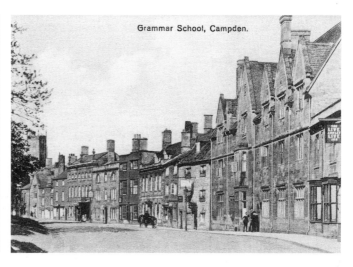

Grammar School, Campden.

The buildings that once housed the grammar school adjoin the former Live and Let Live Inn. Both buildings still stand little altered, albeit serving different purposes. The school building is presently the showroom for an antiques business appropriately named School House Antiques, and the inn is a clothes shop. The former grammar school merged with Moreton Secondary School in 1965 to form Chipping Campden Comprehensive. *(Chamberlain, Campden)*

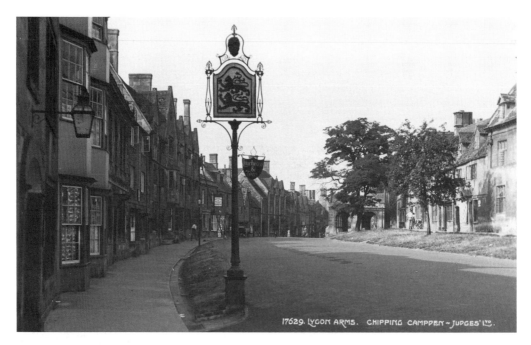

17629. LYGON ARMS. CHIPPING CAMPDEN – JUDGES' LTD.

The Lygon Inn, primarily built during the late eighteenth and early nineteenth centuries, has variously been known as the George and the Hare & Hounds. A former coaching inn, it was renamed the Lygon Arms probably in honour of Major-General Edward Pyndar Lygon (1786–1860) a Waterloo veteran and member of the Beauchamp family. The sign shows the Beauchamp family crest of two lions, and the grade II listed frontage remains unaltered with its centred carriage arch entrance leading to extensions at the rear. It continues to be a welcoming hostelry, retaining its traditional Cotswold atmosphere as a small, family-run hotel, restaurant and public bar. There is also a Lygon Arms Hotel at Broadway that has a similar connection with Major-General Edward Pyndar Lygon. *(Judges Ltd., Hastings)*

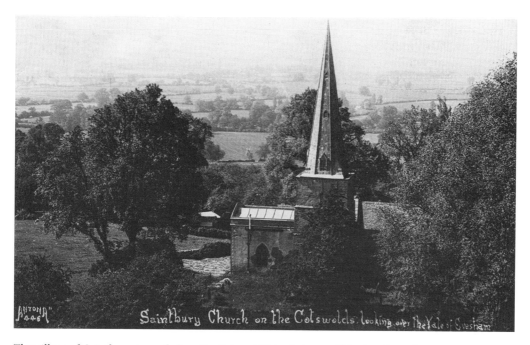

Saintbury Church on the Cotswolds looking over the Vale of Evesham

The village of Saintbury is nestled on the Cotswold Edge between Chipping Campden, Weston Subedge and Broadway. From St Nicholas' Church there are spectacular views of the Worcestershire countryside with the thin line of the former Roman road Buggilde Street (or Buckle Street by its Anglo-Saxon name) just discernable as it traverses the Vale of Evesham. The arched doorways of St Nicholas' Church date from Norman times, and the church is topped with an impressive spire which is decorated with intricate tracery, while inside is a fourteenth-century chancel. Its octagonal font dates from the fifteenth century. *(Antonia)*

The Cotswold Way crosses Fish Hill and passes under Broadway Tower (4 miles) before descending into the High Street of Broadway village.

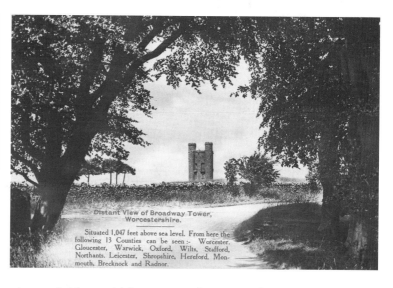

Distant View of Broadway Tower, Worcestershire.

Situated 1,047 feet above sea level. From here the following 13 Counties can be seen :- Worcester, Gloucester, Warwick, Oxford, Wilts, Stafford, Northants, Leicester, Shropshire, Hereford, Monmouth, Brecknock and Radnor.

An equally impressive vantage point from which to survey the surrounding countryside is the architectural folly Broadway Tower, designed by James Wyatt and completed in 1798. As the caption on the card explains, the view encompasses thirteen counties. *(Green's of Broadway)*

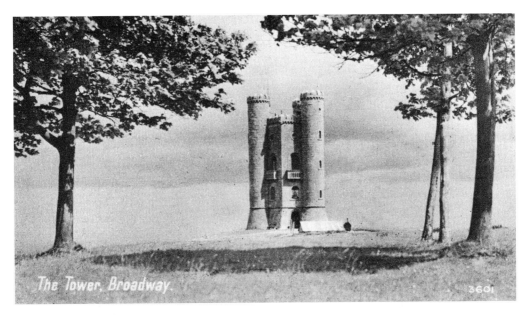

Broadway Tower, sometimes referred to as the 'Highest Little Castle in the Cotswolds', is the centre-point of Broadway Tower Country Park, which comprises a grassy hillside, picnic site, restaurant and deer enclosure. William Morris (1834–96), and his pre-Raphaelite Brotherhood friends Dante Gabriel Rossetti (1829–1919) and Edward Burne-Jones (1833–98) once occupied the tower. The influence of William Morris's Arts and Crafts movement has left a lasting impression on the Cotswolds, with the founding of the Broadway colony of artists and in the architectural styles of many buildings in the district. Many local artisans, potters and artists followed the arts movements of the Cotswolds such as furniture designer Sir Sydney Gordon Russell (1892–1980) who established a workshop next to the Lygon Hotel in Broadway. *(English Series, Photo-Precision Ltd., St. Albans)*

This view shows Broadway from the vantage point of the ancient ridgeway that crosses Broadway Hill and Middle Hill; it is also the course of the trading route Buckle Street. The origins of many of these old Cotswold trackways are lost in antiquity, some even date from the late Stone Age, formed by the passage of animals and humans treading the high ground between hill settlements throughout the region. The Romans later used many of these ancient tracks or greenways (drover's roads) as the foundation of their military roads through the Cotswolds. *(English Series, Photo-Precision Ltd., St. Albans)*

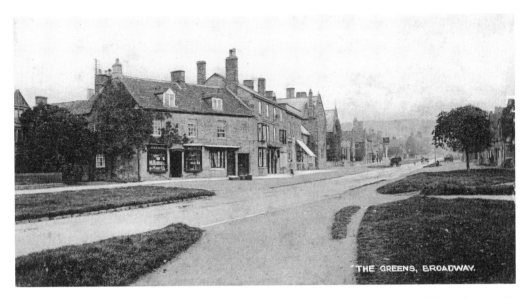

Broadway in Worcestershire is one of the most picturesque villages in the Cotswolds, and certainly among the prettiest in England. Today the well-manicured lawns form the front borders to a range of beautiful old stone buildings. *(Tritone Art Series)*

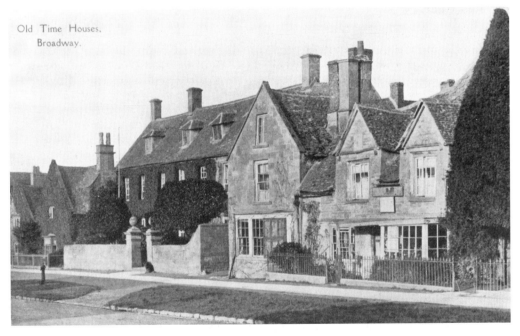

The old time houses of Broadway mainly date from the seventeenth and eighteenth centuries. Appearing urban in character, they are tightly packed together along the High Street and are built from golden-coloured local limestone and roofed with dark stone tiles. Whether a high-status country house, elegant terrace or an artisan cottage, the stone of the Cotswolds has a unifying effect on all of its buildings, new or old, or of different architectural styles – the overall impression is one of commonality. However, there is a difference in colour and gradation in Cotswold stone, from pale yellow, magnolia to ochre and terracotta that adds a unique quality to every building in Broadway, as indeed it does for stone buildings in all Cotswold villages and towns. *(John Morris & Co., Broadway, Worcestershire)*

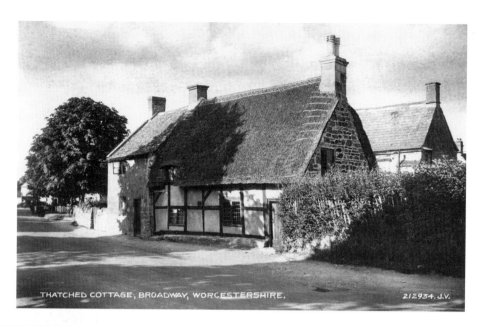

THATCHED COTTAGE, BROADWAY, WORCESTERSHIRE. 212934. J.V.

The Cotswold Way leaves the High Street at Church Street (6 miles) passing the Crown & Trumpet pub and St Michael's Church before it turns onto a footpath leading through Broadway Coppice – on its way to Stanton.

Despite the abundance of stone roof tiles, many Cotswold houses used thatch and wood-framed stucco for walls, an influence of local building practise in the Severn Vale and Evesham Vale. Smaller and humbler buildings used less expensive thatch than stone slates, and thatched roofs were much more common in the Cotswolds a hundred years ago. The Cotswold buildings themselves offer the greatest appeal to Broadway's visitors. *(Valentine's)*

Church Street leads off the High Street towards St Michael & All Angels' Church, which was built in comparatively recent times – 1840. This church was more accessible to the town's people than the former parish church of St Eadburgha, which was located a little under a mile from the town at Bury End on the same road. The building immediately on the left is one of Broadway's much-acclaimed historic pubs, the Crown & Trumpet, which dates back to the seventeenth century. *(Photochrom Co. Ltd., London & Tunbridge Wells)*

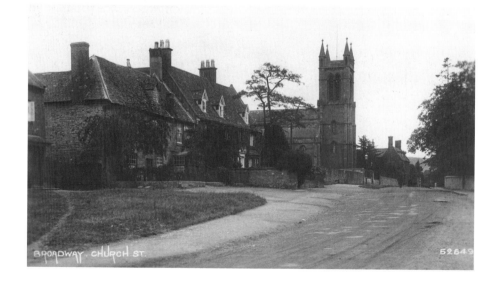

BROADWAY. CHURCH ST. 52649

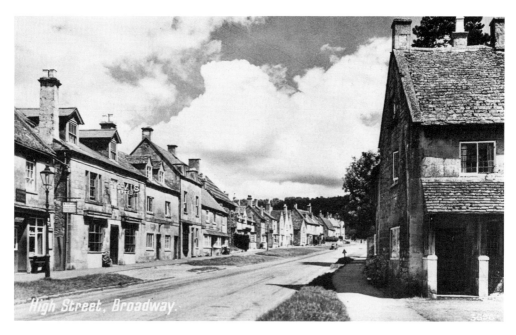

Two views of the High Street in Broadway. The street is over a mile long and once joined the ancient ridgeway and Five Mile Drive, which descended from Fish Hill. Formerly the turnpike road between Worcester and London, it comes as no surprise that Broadway takes its name from this broad road. The High Street was also part of the main A44 road through the village – since bypassed. The first postcard view is looking towards Fish Hill . . . *(English Series, Photo-Precision Ltd., St. Albans)*

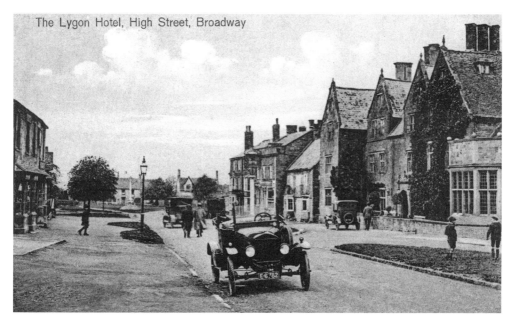

. . . and this view from outside the Lygon Hotel is looking towards the Green. In summer months, like many other Cotswold villages and towns, the High Street sees many visitors, but despite these numbers, the village cannot fail to give a lasting impression of what a perfect village should look like, and it certainly deserves its title 'The Jewel of the Cotswolds'. *(Publisher unidentified)*

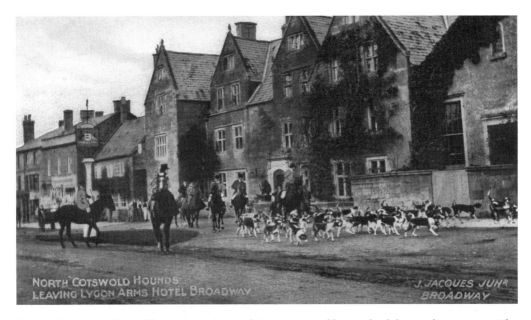

Fox-hunting in the Cotswolds was a country tradition, supported by much of the rural community. The North Cotswolds Hunt is seen here leaving the Lygon Arms Hotel. The hunt did not disband following the 2004 Hunting Act and its members' stated objectives are to lobby to reintroduce lawful hunting to the district. The hunt's kennels continue breeding foxhounds in order to preserve their pedigrees. *(Jacques Junr.'s Broadway)*

The Lygon Arms Hotel, originally called the White Hart, can justly lay claim to be one of England's most celebrated inns. It dates back to at least the sixteenth century and is distinctly Tudor in appearance but with fragments of fourteenth-century stonework. The inn served as a hostelry to wealthy wool merchants who frequently travelled between the wool towns of the Cotswolds, and who perhaps, from the early nineteenth, century stayed – on occasion – at the similarly named Lygon Arms Inn at Chipping Campden. *(Russell & Sons, Broadway, Worcestershire)*

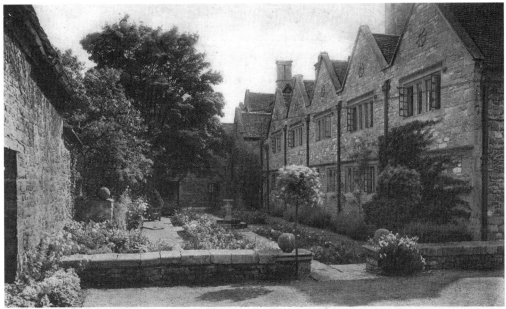

FORMAL GARDEN, LYGON ARMS, BROADWAY

Seen here is the formal garden of the Lygon Arms, the wing having been built in the early part of the twentieth century, and the east gables of the old inn. Today the hotel is better known as the Barceló Lygon Arms, with a world-renowned reputation for exceptional service, accommodation and dining for its clientele from around the world. (*Russell & Sons, Broadway, Worcestershire*)

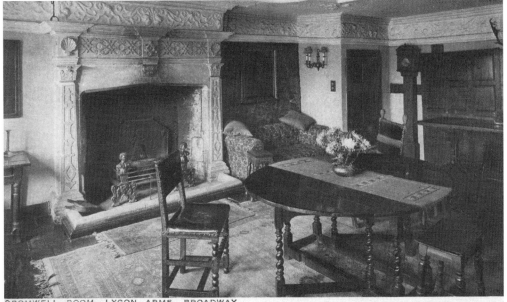

CROMWELL ROOM, LYGON ARMS, BROADWAY

The historic Cromwell Room of the Lygon Arms with its Elizabethan fireplace. The plasterwork dates from 1620 and the Lord Protector slept in the room on 2 September 1651, the night before the Battle of Worcester and the defeat of Charles I – the room is still available to guests. Charles I also visited the hotel earlier in the conflict to meet with his supporters; the room he used is the appropriately named Charles I Sitting Room. (*Russell & Sons, Broadway, Worcestershire*)

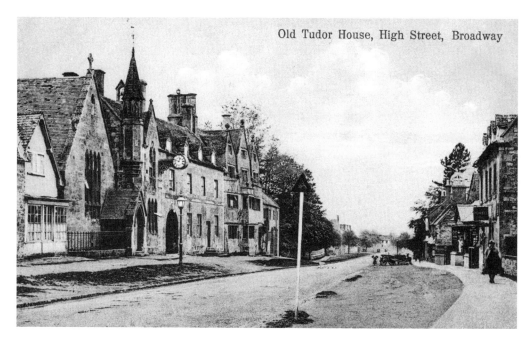

Old Tudor House, High Street, Broadway

On the far right in this view of the High Street is the Horse & Hounds. The name of the pub is yet another reference to the Cotswold fox-hunting tradition. The Old Tudor House is now home to Trinity House, an art gallery. This is just one well-known gallery in Broadway that perpetuates the village's reputation as a Cotswold centre of the arts. *(Publisher unidentified)*

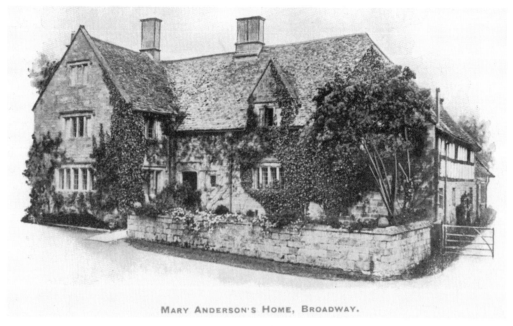

MARY ANDERSON'S HOME, BROADWAY.

Mary Anderson (1859–1940), a successful and famous American stage actress, together with her husband Antonio Fernando de Navarro, made Court Farm in Broadway her home. In their time there, the couple were visited by a notable circle of musical and literary friends and acquaintances. A devout Christian, Mary had a chapel with stained-glass windows designed by Paul Woodroffe (1875–1954), a book illustrator and stained-glass artist, built for her in an upper storey room of the house. *(Publisher unidentified)*

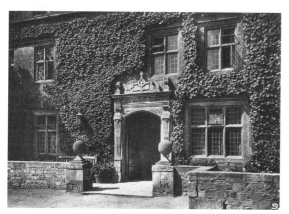

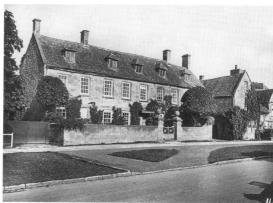

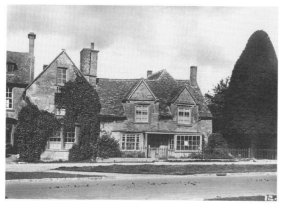

Often small individually captioned photographs enclosed in an envelope were sent as an alternative to a single postcard, sometimes as a group of separate photos, or in a folding strip. Five numbered photos of an envelope originally containing '12 Beautiful Photo Snapshots of Broadway for your album' are shown here. Featured are: 3. Winding Road over the Cotswolds; 8. Church Road; 9. Old Doorway 'Lygon Arms'; 11. Picton House (formerly Old Bell Inn); 12. Yew Tree Cottage. *(Publisher unidentified)*

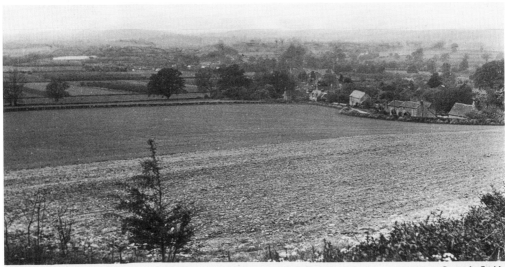

BDN.26 General View from Bredon Hill, BREDON Copyright Frith's.

A view looking towards the north-west over the flat Avon and Severn valleys and towards the Malvern Hills in the far distance, from the elevated view point of Bredon Hill – a Worcestershire outcrop of the Cotswolds. The hill is part of the Cotswolds AONB, although the natural process of erosion has isolated it from the Cotswold ridge. In common with many of the hilltops throughout the Cotswolds, there are remains of an ancient earthworks, including one called Kemerton Camp, an Iron Age fort abandoned after the Roman occupation. *(Frith's Series, Francis Frith & Co. Ltd., Reigate)*

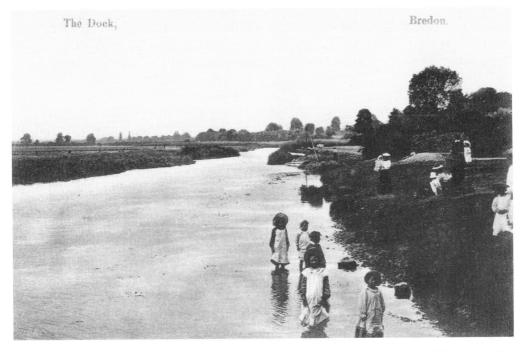

The valley of the River Avon at Bredon is scoured by ice-age glaciers and the action of the river and is conspicuously flat in every direction except towards the east, where Bredon Hill and the Cotswold Edge rise abruptly from the valley floor. The Old Dock at Bredon runs alongside Dock Lane and the Avon. *(Arthur D. Wilkes, Post Office, Bredon, posted 1914)*

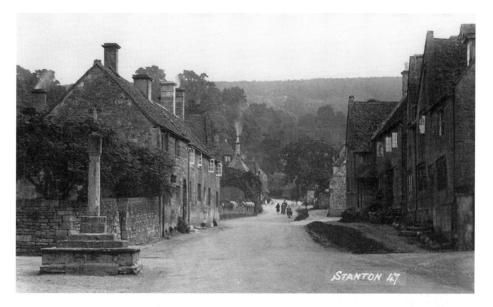

Stanton is a charming old Cotswold village with a wealth of old buildings and an ancient Market Cross at its heart. The villagers are making their way up to the Green – perhaps a worthwhile effort as the village pub called the Little Mount is below the wooded slopes of Shenberrow Hill. The following two views are of the track through the centre of the village between Stanway Road and the unmetalled track to the nearby village of Snowshill. This is the High Street looking west taken in the 1930s . . . *(Publisher unidentified, dated 3 Oct 1936)*

. . . and three years later with seemingly little noticeable difference – even the same windows of the houses are open. Today little has changed and the village street remains timeless and unspoilt. The village is a little less than 4 miles south of Broadway and shares similar architectural styles of buildings to its much larger neighbour. *(Hill's Crown China & Art Shop, Broadway, posted 1938)*

The Cotswold Way descends from the Iron Age fort on Shenberrow Hill and enters into Stanton village (9½ miles) from the south-east.

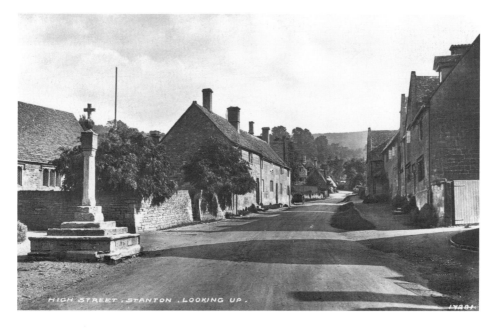

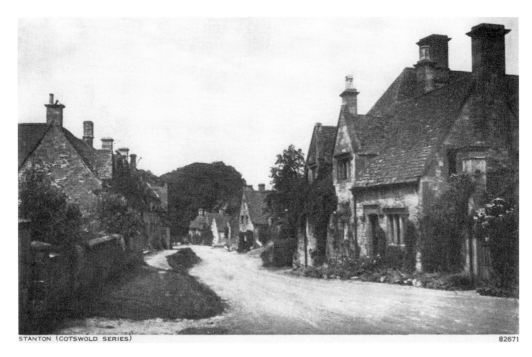

STANTON (COTSWOLD SERIES) 82671

Looking down Stanton High Street from the Green. This view is in the opposite direction to the two previous views. *(Photochrom Co. Ltd., Tunbridge Wells, Kent)*

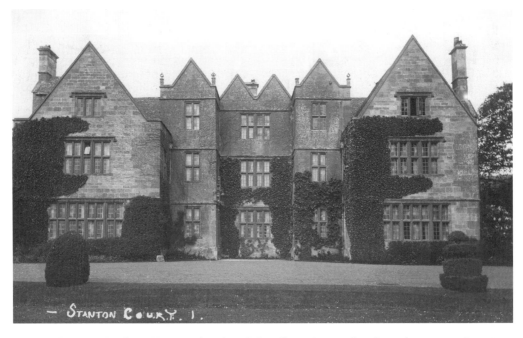

— STANTON COURT. 1.

Stanton Court is a Jacobean House at the edge of the village. Occupied in the mid-seventeenth century by the Izod family and the Wynniatts in the eighteenth century, it was extensively altered in the first decades of the twentieth century under the direction of Sir Phillip Stott, who was also responsible for the restoration of many other buildings in the village. *(Frank Packer, Photographer, Chipping Norton, posted 1934)*

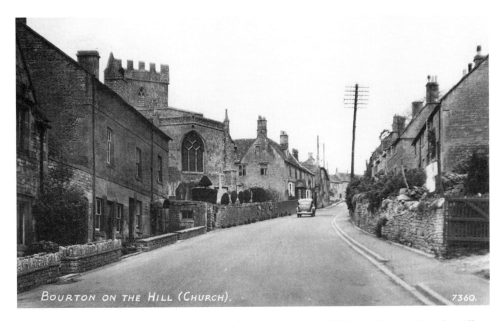

The busy A44 passes through the centre of Bourton-on-the-Hill, but despite this, the village retains its Cotswold charm, overlooking the Evenlode Valley. Parts of the church of St Lawrence date back to 1157, at the time when the church was originally dedicated to St Mary. The pillars on the south of the nave date from this time but the church underwent extensive alterations in the fourteenth and fifteenth centuries. *(The RA (Postcards) Ltd., London EC4)*

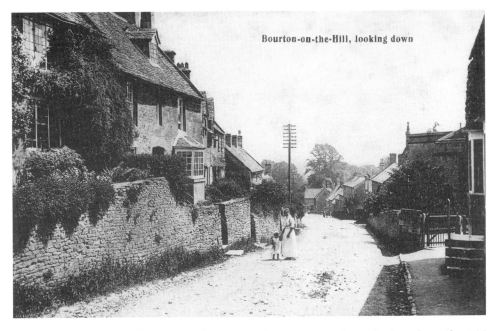

The village viewed from the opposite direction to the previous postcard, looking down the A44 road from the top of the hill and the Horse & Groom pub. The scene surprisingly, has changed little despite road widening. However, standing in the centre of the road as this mother and child are, might prove to be far more hazardous with today's substantial increase in road traffic. *(Publisher unidentified)*

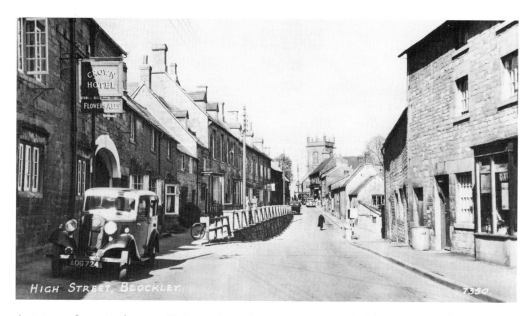

A picture of an utterly unspoilt Cotswolds village largely untouched by tourism and commercial exploitation (even today). Here we see the High Street leading onto Bell Lane with the Crown Hotel on the left. The parish church is dedicated to St Peter and St Paul, parts of which date back to Norman times, although it was extensively altered in the eighteenth century. Blockley, originally founded on the wool industry, developed in a similar way to other nearby villages. However, as this industry declined locally – from the Middle Ages onwards – the village gradually adapted to silk manufacture and Blockley grew and expanded with this more prosperous trade. *(The RA (Postcards) Ltd., London EC4)*

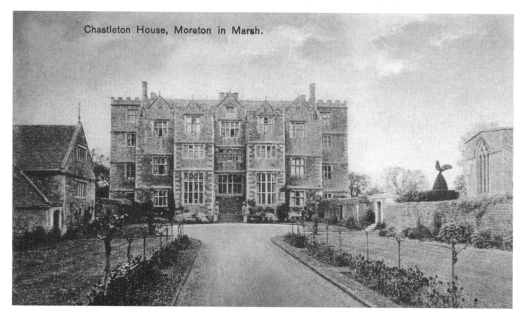

Castleton House (built 1607–12) near Moreton-in-Marsh has changed little since it became home to a wealthy wool merchant. Rescued from decay and ruin by the National Trust in 1991, and now open to visitors, it serves as a perfectly preserved example of a Jacobean country house. The exterior, rooms, kitchen and much of its contents and the topiary and vegetable gardens are in perfect harmony with the unspoilt Oxfordshire Cotswolds rural setting. *(Publisher unidentified)*

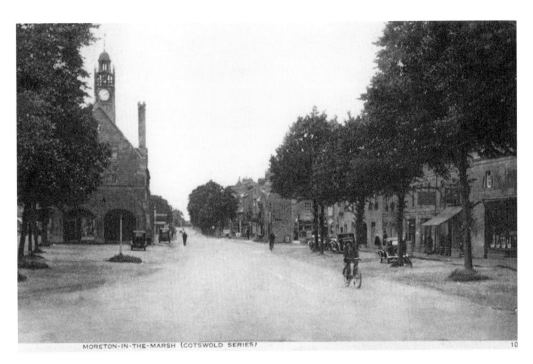

The small, busy market town of Moreton-in-Marsh lies at the head of the Evenlode Valley. Bisected by
the ancient Fosse Way (today's A429 busy main route through the town), it is ideally placed as a tourist
centre for visitors to the Cotswolds. *('Cotswolds Series' Photochrom Co. Ltd., London & Tunbridge Wells)*

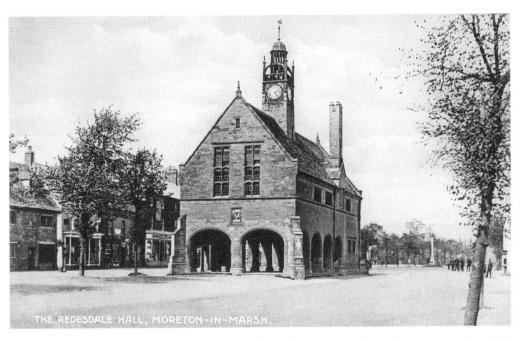

Moreton received its market charter in 1227. The Market Hall (architect, Sir Ernest George) was built in 1887
under the patronage of Sir Algernon Bertram Freeman Mitford (Lord Redesdale of Batsford Park). There is
still a market every Tuesday on the broad High Street in front of Redesdale Hall. *(Publisher unidentified)*

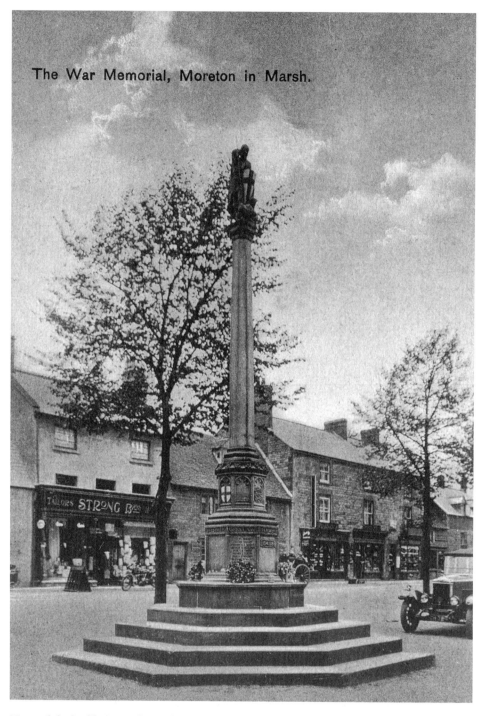

The War Memorial, Moreton in Marsh.

Many of the buildings on the High Street date from the seventeenth and eighteenth centuries. The residences, coaching inns and shops were built to serve the age-old route between London and Worcester. In the foreground is the war memorial dedicated to soldiers of Moreton and Batsford killed in the First World War, and subsequently to those killed during the Second World War. The memorial was unveiled on the 26 March 1921 witnessed by the people of Moreton and surrounding area. *(Publisher unidentified)*

2

Cheltenham & the Heart of the Cotswolds

'Enter Cheltenham by Pittville Street leading to High Street almost opposite the Plough Hotel. Just after passing the High Street, the Church of St Peter demands some notice with its Norman Architecture. The Imperial Winter Gardens with concert hall, skating ring, etc. at the south end of the promenade. The College on the east side of the Bath Road, with its lofty new chapel, opened about two years ago. Cheltenham is a great resort for retired military and naval officers.'

(*Littlebury's Cyclist's Guide, Route Book for the West Midlands walking the cities of Worcester, Hereford & Gloucester,* each a centre for the cyclist, together with copious notes on the state of roads, dangerous hills etc., and objects of interest en route. Harold Freeman MA, Oriel College Oxford, 1898)

From Stanton (Chapter 1), the Cotswold Way continues its undulating course to Stanway and Hailes Abbey and by way of the Pilgrim's Way to Winchcombe. Skirting the suburbs of Cheltenham, it crosses the heights of Cleeve Common on its way to the village of Birdlip.

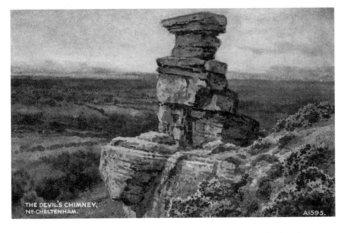

The Devil's Chimney is a famous and prominent Cheltenham landmark: it is an exposed pillar that clearly shows the underlying geological composition of the Cotswold Edge. (*'Art Colour' Valentine & Sons Ltd., Dundee & London, from a water colour by E.T.W*)

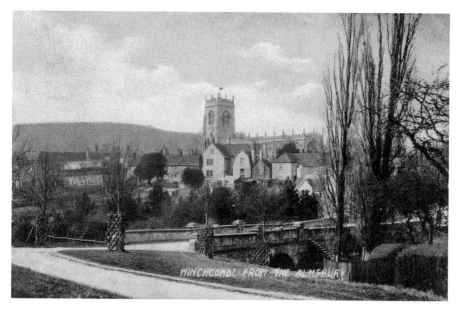

Winchcombe, St Peter's Church and the bridge over the River Isbourne on Vineyard Street. Close by is the entrance gate and driveway to Sudeley Castle (once home to Catherine Parr, the last wife of Henry VIII), one of Winchcombe's most popular attractions. Most of the castle dates from the mid-fifteenth century and the residential part is Tudor, home to the Dent-Brocklehursts and Lord and Lady Ashcombe. The young trees planted alongside the bridge have grown and nowadays greatly obscure the view of the town from this location. *(G. Tovey & Son, Winchcombe, posted 1908)*

After descending on the old Pilgrim's Way from the ruins of Hailes Abbey, the Cotswold Way passes through Winchcombe High Street (17½ miles). Leaving the town by Vineyard Street and the Isbourne Bridge, the way heads south to Belas Knap.

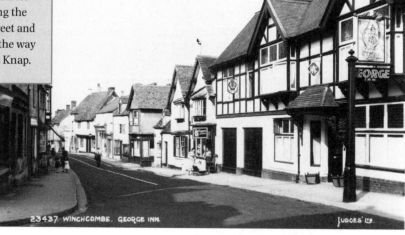

The former George Inn is a grade II listed building dating from the late fifteenth and sixteenth centuries and built as a hostel for pilgrims to Winchcombe Abbey and nearby Hailes Abbey, where the reliquary housed a phial that allegedly contained the blood of Christ. The front façade of the George Inn was unsympathetically and extensively altered in the late nineteenth century and the early part of the twentieth century during the building's later years as a hotel. To the other side of the passage is a shop with a seemingly older frontage and an entrance door flanked by two windows. *(Judges Ltd., Hastings)*

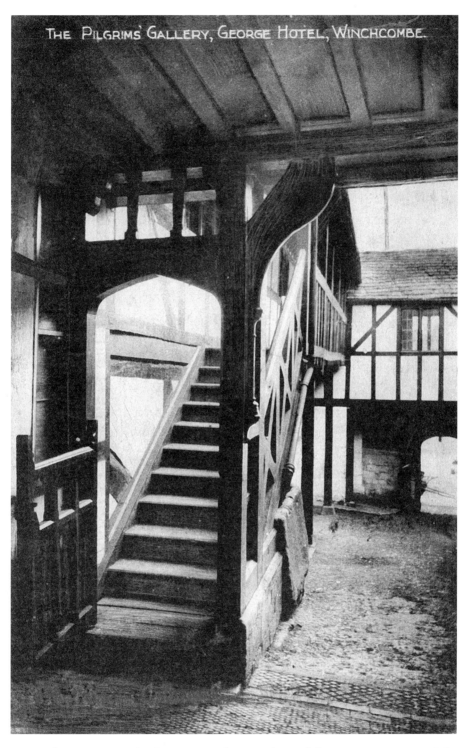

THE PILGRIMS' GALLERY, GEORGE HOTEL, WINCHCOMBE.

In complete contrast to the disappointing frontage, beyond the open entranceway of the old George Hotel there is a splendid heavy framed external gallery – referred to here as the Pilgrims' Gallery – with a tiled roof, beyond which is a two-storey wing with heavy external doors and rustic casement windows. *(G. Tovey & Son, Winchcombe)*

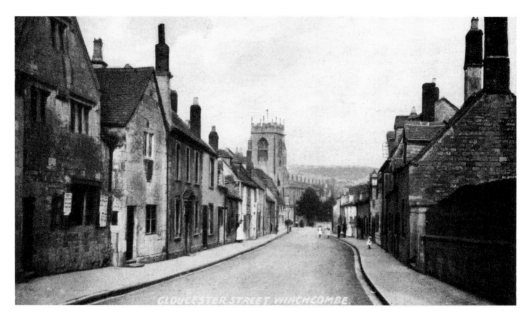

Gloucester Street, Winchcombe. The blurb on the back of this postcard proclaims Winchcombe to be 'an old fashioned Gloucestershire town, in the midst of the Cotswolds Hills of considerable importance in Saxon times. Offa, the Mercian King, had a residence here; and his son, Kenulph, founded a Benedictine Abbey in 811, which became famous as a place of pilgrimage to the shrine of the little murdered king Kenelm' – allegedly! St Peter's Church stands adjacent to the site of the now totally lost Winchcombe Abbey. *(The 'Mercia' Series, F.C. Rickett, Claverdon, Warwick & Stratford-on-Avon)*

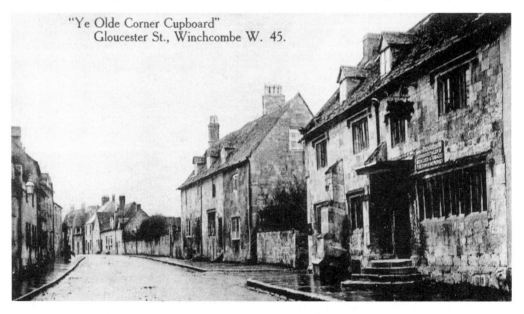

A number of roads all join to become the principal route through Winchcombe. Buildings along the route of the turnpike road between Broadway and Cheltenham were deliberately built or adapted to take advantage of the passing trade. The local justices licensed this mid-sixteenth-century farmhouse as an inn and the conditions of its licence were that it could remain open if it provided accommodation for a traveller. The Corner Cupboard Inn has remained open as licensed premises to this day, a popular pub and restaurant offering a range of real ales and excellent food. *(G. Tovey & Son, Winchcombe)*

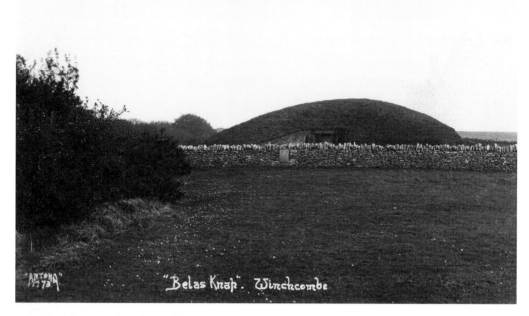

"Belas Knap". Winchcombe

The 180ft-long, 60ft-wide Neolithic long barrow between Winchcombe and Charlton Abbots on the edge of Cleeve Hill is testimony to the occupation of the area by people of the New Stone Age. The influence of man on the shaping of the landscape of the Cotswolds has been continuous from prehistoric times to the present, and the signs of early man are apparent from the significant number of hilltop burial mounds and hill forts in the district. *(Walker, Stratford-upon-Avon)*

Cleeve Hill is a grassy common with exposed outcrops of limestone on the western escarpment, and highest point of the Cotswolds (approximately 1,080ft) that overlooks Bishops Cleeve and the Severn. The common is also home to a golf course and an Iron Age hill fort, and to the south-west there are views of Cheltenham and the racecourse. *(Philco Publishing Co., Holborn Place, London, W.C.)*

Passing Belas Knap (20 miles) the Cotswold Way swings in a 5-mile loop around Cleeve Common.

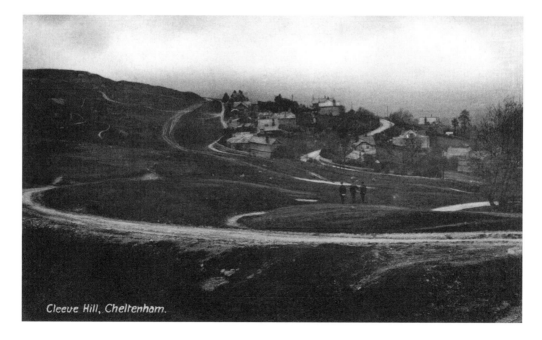

Cleeve Hill, Cheltenham.

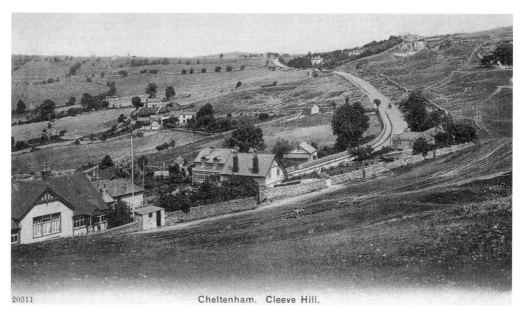

20311 Cheltenham. Cleeve Hill.

The top of Cleeve Hill is a relatively flat common, but there are some bare outcrops of Cotswold stone at Castle Rock, which attract rock-climbers. For the less adventurous, there is an extensive network of footpaths and tracks around the common. *(Publisher unidentified, posted 1905)*

The Cotswold Way crosses here (24 miles) and passes Castle Rock along Cleeve Cloud to reach an Iron Age hill fort (25 miles). After Happy Valley, it turns away from Cheltenham as it descends through Dowdeswell Wood to cross the River Chelt and the A40 (29 miles).

The two views on this page are seen from the edge of the golf course – established in 1891 – and show a group of houses, a hotel, a youth hostel and guest houses – today there is Cleeve Hill House Hotel and Malvern View Hotel. Newly built houses are visible in the far distance, the start of the process of ribbon development – these were largely middle-class residences with a view, built for those who could afford a motor car. That said, the Cheltenham & District Light Railways (C&DLtR) ran a tram service from Cheltenham town centre to the top of Cleeve Hill via Southam Road and Prestbury. *(F. Frith& Co. Ltd., Reigate)*

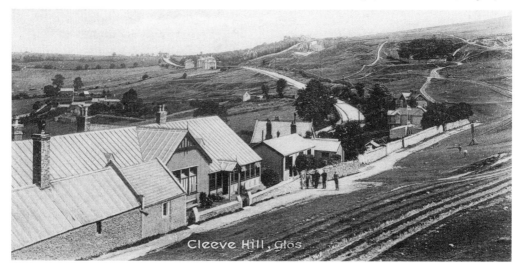

Cleeve Hill, Glos.

The old High Street Assembly Rooms were demolished by the end of 1900 having outlived their usefulness. Cheltenham Town Council had decided on a new building designed by Frederick William Waller to be erected in Imperial Square next to the glass Winter Gardens. The Town Hall included offices – from where this 1930s advertisement for a guidebook of Cheltenham originated – a spa for Cheltenham waters and a large main hall with a coved ceiling supported on Corinthian columns. *(Advertisement from Ward Lock's illustrated guide)*

" Rest, Beauty, and Elegant Entertainment.''
—Lord Horder.

CHELTENHAM SPA
in the Heart of the Incomparable
COTSWOLDS
Send for free guide to Dept. L.W., Town Hall, Cheltenham

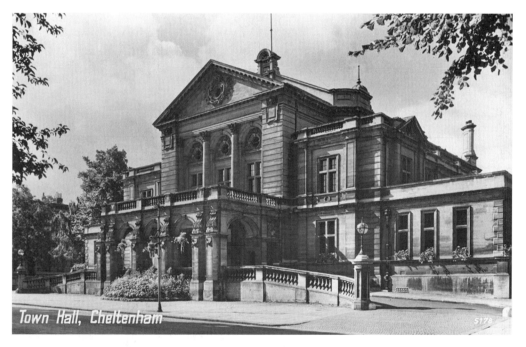

The classical Baroque-style Town Hall, designed to hold 1,000 people, opened in December 1903. The main hall supported on Corinthian style columns is used extensively for every kind of function from dances and banquets to exhibitions, especially during the annual Cheltenham Festival. The Central Spa opened in 1906 to dispense the spa water from Doultonware urns stood on a counter. *(Photo-Precision Ltd., St. Albans)*

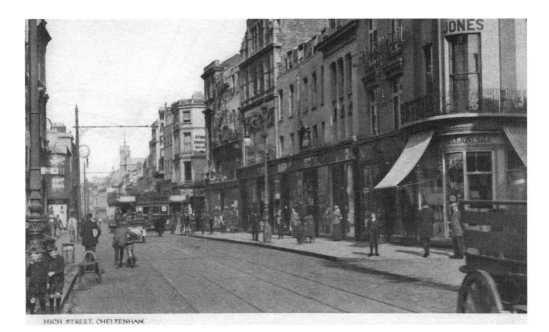

HIGH STREET, CHELTENHAM

In common with many fashionable and prestigious spa towns, Cheltenham High Street has a wide selection of exclusive shops for its permanent residents and visitors. The discovery of mineral springs in the first quarter of the eighteenth century and the subsequent visit of King George III and Queen Charlotte in 1788 placed Cheltenham firmly on the map as a fashionable retreat for the wealthy. These days, part of the High Street is closed to traffic and some buildings have been demolished and redeveloped, but the town retains some of the finest shops in the Cotswolds. *('Pelham Series', Boots the Chemists)*

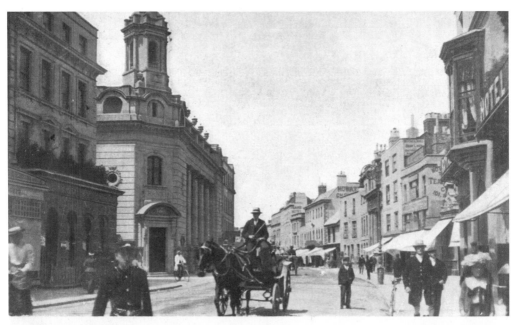

THE HIGH STREET, CHELTENHAM. BURROW, CHELTENHAM. ROYAL SERIES 22.

The buildings on the left here are Barclays and Lloyds banks, both standing at the corner of Rodney Road and the High Street. The photographer who captured this scene at the turn of the twentieth century stood in what is now a pedestrianised area of the High Street. *(Royal Series, Burrow, Cheltenham)*

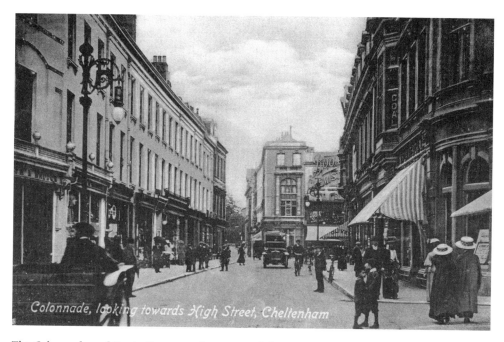

The Colonnade and Boots Corner at the corner of the High Street and the junction of Clarence Street and North Street, a busy shopping area of Cheltenham. A much grander building and frontage has replaced the Boots building seen here, but the new building remains a branch of the popular chemists. *(Publisher unidentified)*

A view looking towards the Colonnade from the lower Promenade. Cheltenham has a wealth of white Georgian terraces consisting of houses and shop frontages, and the shops in the Promenade are arguably the most elegant in the town. *(Royal Series, Burrow, Cheltenham)*

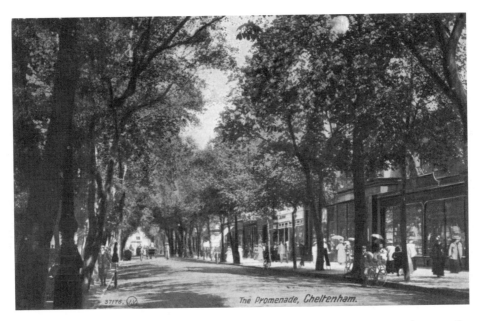

The (Imperial) Promenade, a tree-lined carriage drive, was built in 1818 as a route between the Colonnade and Sherbourne Spa (just under half a mile south of the High Street). Sherbourne Spa was later demolished and replaced with the luxury Queen's Hotel in 1836, which stands opposite Imperial Gardens. *(Valentine & Sons Ltd., Dundee & London)*

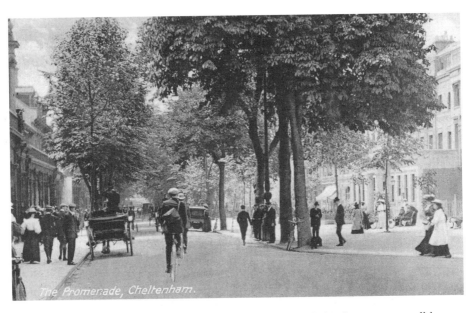

By the late-1820s, the first fashionable store had arrived in Cheltenham, now a well-known and established name: Cavendish House. With drapers, department stores, jewellers, hotels and private residences quickly following, the Promenade had become Cheltenham's most prestigious thoroughfare. Sometimes called 'the Bond Street of the West', the Promenade has acquired an enviable reputation as one of Britain's favourite high streets. *(The Milton 'Bromo' Series, Woolstone Bros, London E.C.)*

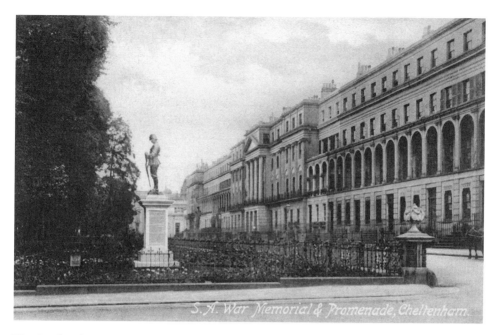

The South African War memorial, a bronze cast figure of a Boer War soldier standing on a marble plinth was unveiled on 17 July 1907 at the north end of the Long Garden in front of the Municipal Offices. Completed in 1823 the Municipal Offices occupy only part of the row: over sixty houses share the façade and the building is regarded as one of the finest examples of Regency architecture in England. *(J.J. Banks & Son, Imperial Library, Cheltenham)*

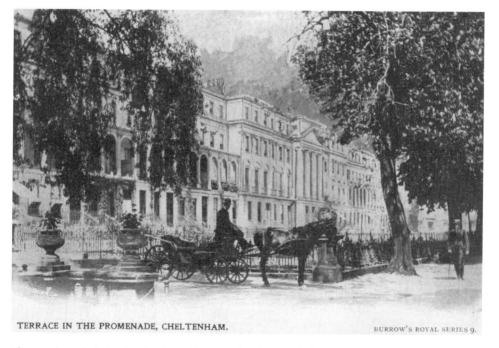

TERRACE IN THE PROMENADE, CHELTENHAM. BURROW'S ROYAL SERIES 9.

The south end of the Cheltenham Municipal Offices and the Long Garden, which forms the crescent, seen from the Promenade. *(Burrow's Royal Series, posted 1909)*

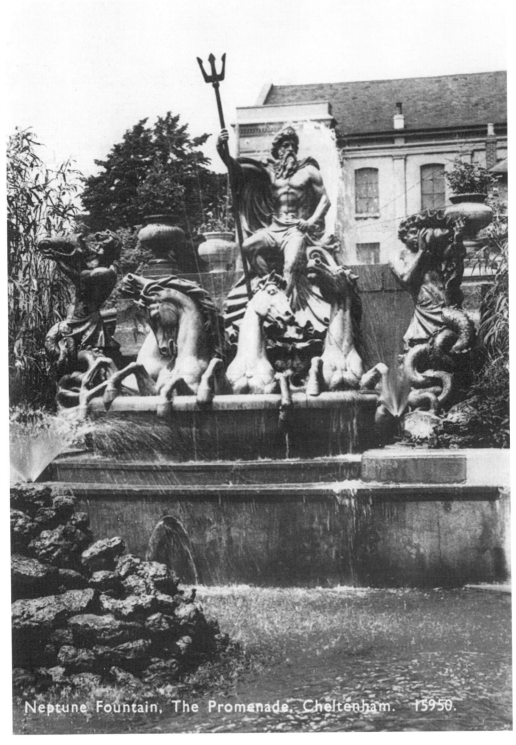

Neptune Fountain, The Promenade, Cheltenham. 15950.

The Portland stone Neptune Fountain in the Promenade was erected in 1893 and is said to have been modelled on the Trevi Fountain in Rome. *(J. Salmon Ltd., Sevenoaks)*

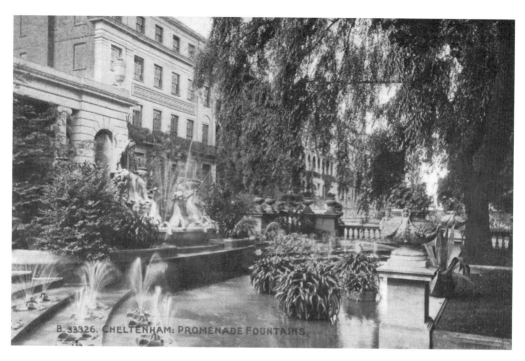

The Promenade fountains and Neptune's statue are at the corner of St George's Road, facing Imperial Lane across the Promenade. *(Celesque Series, The Photochrom Co. Ltd., London & Tunbridge Wells)*

A little further south along the upper Promenade was the former entrance to the Winter Gardens and Imperial Square. *(British Colour Series, Burrow, Cheltenham, posted 1905)*

The view from Queens Square and the Queen's Hotel, looking directly down the upper Promenade. On the right is Imperial Park. *(Celesque Series, The Photochrom Co. Ltd., London & Tunbridge Wells)*

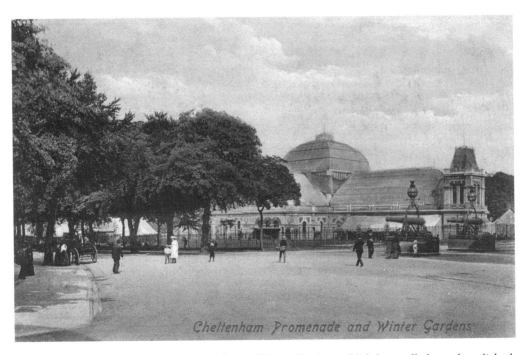

From Queens Square we see the glass and steel Winter Gardens which has sadly been demolished, though Imperial Park remains. The cannon, which stood astride of the front entrance of the Queen's Hotel, were captured at Sebastopol during the Crimean War. *(F. Frith & Co. Ltd., Reigate)*

The Queen's Hotel, built in 1837, had certainly established a reputation for excellence, and offered the best service possible to early touring motorists. *(Ward Lock's Guide, c. 1930s)*

CHELTENHAM.

QUEEN'S HOTEL

Officially Appointed by R.A.C., A.A., & M.U., and T.C. of America.

THE LEADING FIRST - CLASS HOTEL IN THE GARDEN TOWN.

THE Hotel faces the Promenade, and from the Windows commands an uninterrupted view of the Cotswolds. Comfortable Bedrooms. Beautiful Suites. Cosy Lounge. Billiard Room for Visitors only. **First-class Cooking and Service. Garage for 40 Cars.** Private Lock-ups for **20** Cars. Heated, and with Electric Light in Inspection Pits. Petrol and Repairs. **Open all Night.** The Finest Motoring Centre of England. **Famous Cellars of Old Wines** Reasonable Terms.

Telephone—913, 914. STANLEY G. R. HOLMAN,
Telegrams—" Queen's." MANAGING DIRECTOR.

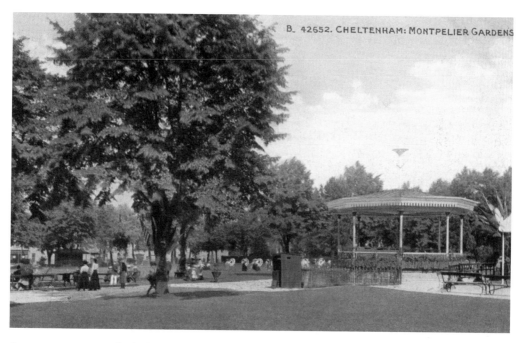

B. 42652. CHELTENHAM: MONTPELIER GARDENS

Concerts continue to be held during the summer months at the bandstand in Montpellier Gardens, constructed in 1864. The gardens are located in a square between Montpellier Spa Road and Montpellier Street which has some of the finest grade I listed Regency buildings in Cheltenham. Originally known as Trafalgar Field, the area was developed by Henry Thompson, a London financier, in the early nineteenth century as a setting for his Pump Room (later replaced with the Rotunda pump room in Montpellier Walk). *(Celesque Series, The Photochrom Co. Ltd., London & Tunbridge Wells)*

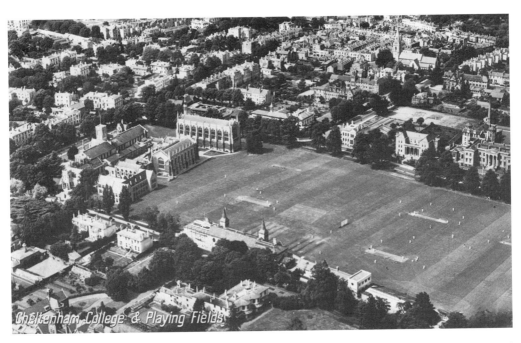

Apart from its fame as a Regency spa, Cheltenham has an enviable reputation as a centre of learning with two famous public schools based in the town. This aerial view shows the playing fields of Cheltenham College, originally an all-boys school, opened in 1841 and today a co-educational establishment. *(English Series, Photo-Precision Ltd., St. Albans)*

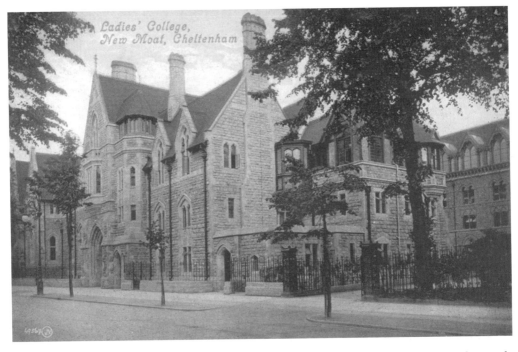

An equivalent school for girls, the Cheltenham Ladies' College, followed in 1854. Miss Dorothea Beale was the first principal of the college from 1858 to 1906. The view is of the college from St George's Road. *('Valentine's Series' Valentine & Sons Ltd., Dundee & London)*

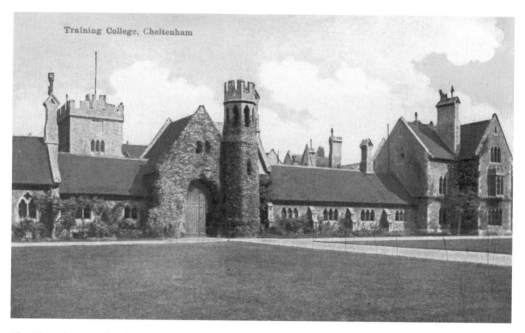

The Church of England Training College for Masters and Mistresses, St Paul's College was built from 1849 in the Gothic revival style with later additions and alterations. The architect was S.W. Daukes. St Paul's Training College is now part of the University of Gloucestershire. *('Pelham Series', Boots Cash Chemists)*

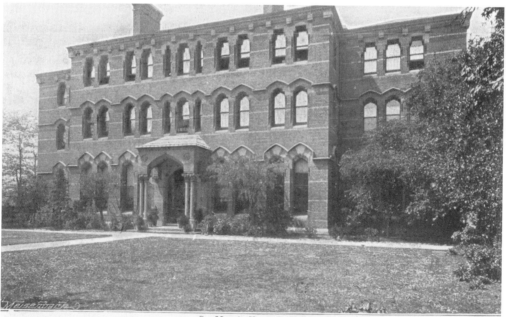

In 1869 the newly built St Mary's Hall in St George's Place was used as purpose-built accommodation for women students from the segregated masters and mistresses college. The College for Mistresses amalgamated with St Paul's College in 1978. The grade II listed building is now called Shaftesbury Hall and has been converted into apartments. *(Publisher unidentified, posted 1905)*

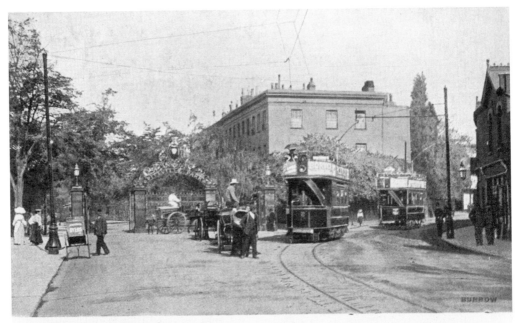

PITTVILLE GATES, CHELTENHAM.

Crossing in quick succession the River Chelt, A40 and course of the Banbury & Cheltenham Direct Railway (closed in 1962), the way heads for Upper Coberley before swinging north-west to Seven Springs (33½ miles).

Pittville Park was opened in 1894 and included gardens, a lake, rowing course and recreational grounds. The tram cars seen here have passed at the Prestbury Road and Winchcombe Street loop; tram no. 2 is heading towards the High Street and the tram furthest away is making its way to Cleeve Hill. *(British Colour Series, Burrow, Cheltenham, posted 1905)*

The C&DLtR had two southerly routes from Cheltenham town centre. The one here left by way of the High Street, London Road and Copt Elm Road and terminated at the GWR station in Charlton Kings. *(Publisher unidentified)*

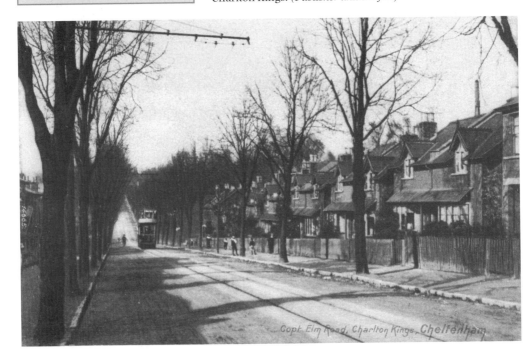

Copt Elm Road, Charlton Kings, Cheltenham

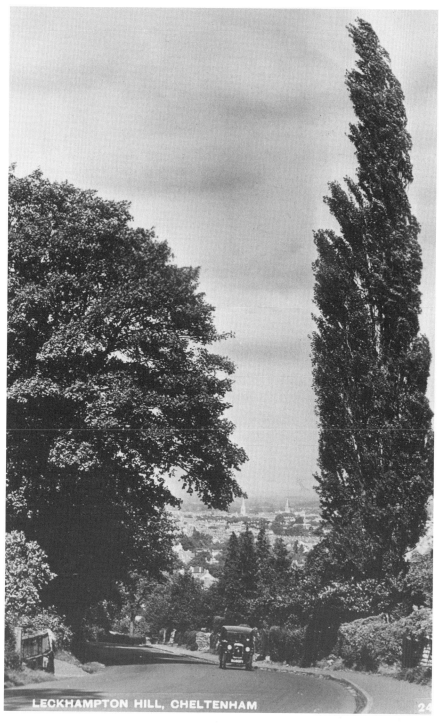

LECKHAMPTON HILL, CHELTENHAM

The other C&DLtR southerly route climbed to Leckhampton Hill by way of Bath Road and Leckhampton Road, terminating in the village. Cleeve Hill and Leckhampton tram services ended in March 1930 and the Charlton Kings service lingered on to the end of the year. With the Cheltenham trams gone, buses and cars became the alternative mode of transport to the Cotswold Edge. *(Publisher unidentified)*

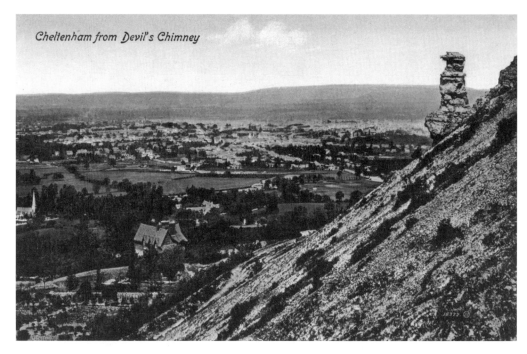

Cheltenham from Devil's Chimney

From Seven Springs the Cotswold Way loops back on itself towards Charlton Kings Common and the Devil's Chimney (35 miles).

The Devil's Chimney, a strange pillar of stone possibly sculpted by quarry men as a folly, overlooks Cheltenham from the disused quarry at Leckhampton Hill. *('Valentine's Series' Valentine & Sons Ltd., Dundee & London)*

A little over a mile to the south-east is Seven Springs, the source of the River Churn which is a tributary of the Thames. *(Celesque Series, The Photochrom Co. Ltd., London & Tunbridge Wells)*

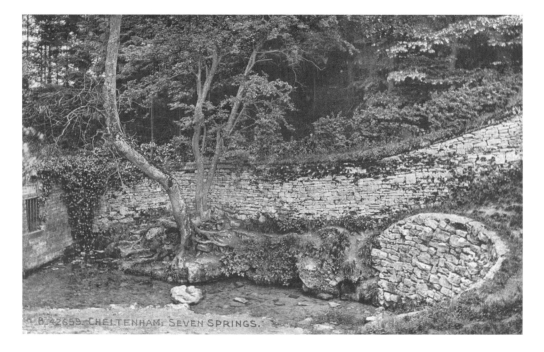

B. 42659. CHELTENHAM: SEVEN SPRINGS.

Drawing water from nearby springs and streams, the fledgling River Churn passes through the small Cotswold hamlet of Coberley, sometimes called Cubberly. A leat from a nearby millpond once fed water to the mill. Also in the distance and at the edge of the village is St Giles' Church in the grounds of Coberley Court. *(Yes or No Series)*

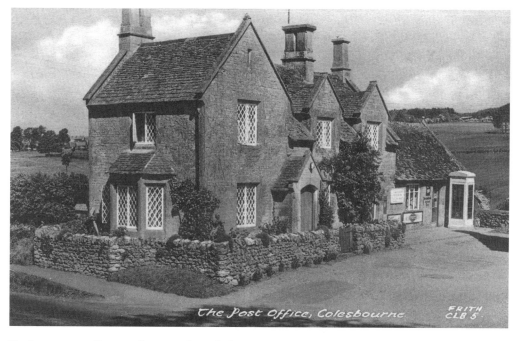

The former post office stands next to the Colesbourne Inn, built in 1827 as a halfway posting stop on the Cheltenham and Cirencester turnpike road. The village straddles the road (today's A435) that crosses the imperceptible River Churn as it enters the village. *(F. Frith & Co. Ltd., Reigate)*

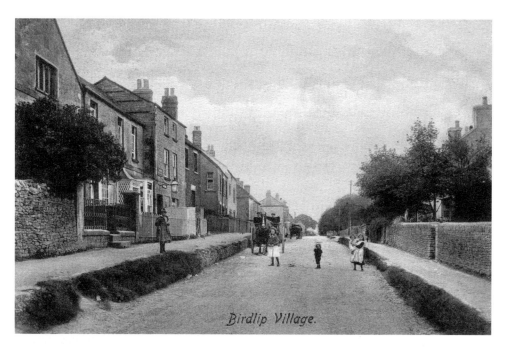

Birdlip Village.

On its way from Leckhampton Hill the Cotswold Way passes the fort at Crickley Hill and the Air Balloon Inn (39 miles). Crossing Birdlip Hill, it skirts the village beside the Royal George Hotel (41 miles).

Birdlip, looking north-west from the old Roman Ermin Street. This ancient thoroughfare took a straight line through the village before descending the Cotswold Edge beyond the Royal George Hotel. *(Publisher unidentified)*

The Royal George Hotel is very much in business today and immediately recognisable from this postcard view. The former coach route descended the Cotswold Edge here on the final 5-mile stage into the centre of Gloucester. The inn was a posting stop and 'link' where additional teams of horses were hitched or un-hitched from teams ascending and descending the escarpment. Later the route was dog-legged by way of Crickley Hill and the Air Balloon public house. *(Publisher unidentified)*

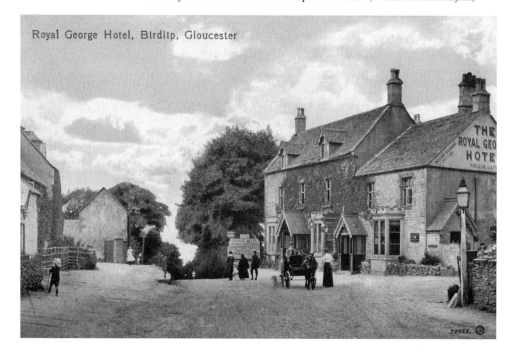

Royal George Hotel, Birdlip, Gloucester

3

The North-East Cotswolds & the Windrush Valley

'The Mole was bewitched, entranced, fascinated. By the side of the river he trotted as one trots, when very small, by the side of a man who holds one spell-bound by exciting stories; and when tired at last, he sat on the bank, while the river still chattered on to him, a babbling procession of the best stories in the world . . .'

(*The Wind in the Willows*, Kenneth Grahame, 1908)

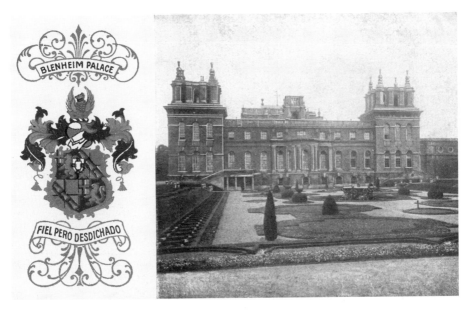

The translation from Spanish of the Churchill family motto 'Fiel Pero Desdichado'
'Faithful but Unfortunate' was coined by the first Duke of Marlborough's father – Winston
Churchill (1620–88) – a Royalist who lost his lands supporting Charles I, and who was
not compensated by Charles II for his faithful loyalty to the Crown. *(Publisher unidentified)*

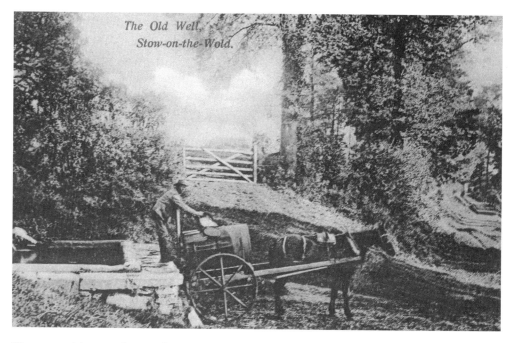

The many visitors to this popular tourist town seldom see the wells in the aptly named Well Lane. This is the first and nearest to the town, while a second, smaller well is further along the lane. These natural springwater wells were in constant use up to the mid-1930s and were the town's main supply of water. For the convenience of the town's residents, a daily filled water tank was pulled up the lane by horse and cart to the centre of the town. *(Publisher unidentified)*

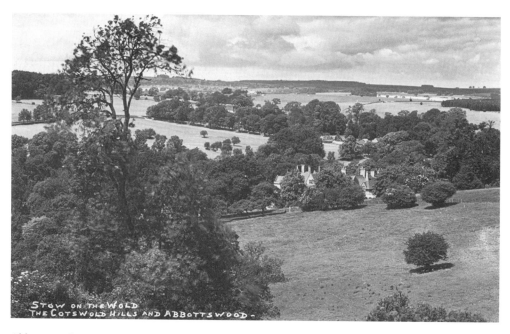

Abbotswood House is nestled in the valley of the River Dikler between Stow-on-the-Wold and the Swells, the perfect location and aspect for a large country house that even the Romans considered ideal, since they built a villa nearby. *(Publisher unidentified)*

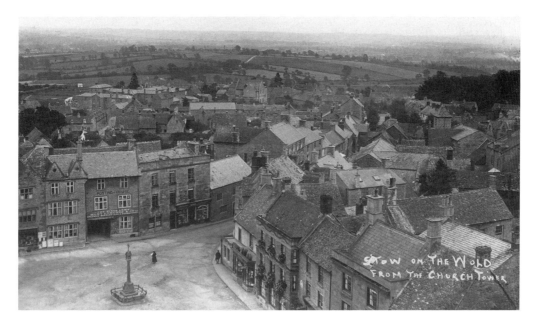

Stow-on-the-Wold is the highest town in the Cotswolds, which makes the view looking down over the rooftops onto the Evenlode Valley from St Edward's Church all the more impressive. The town lies at a crossroads of eight routes through the Cotswolds with the Fosse Way the most famous. The market square below was used for the sale of livestock and goods, and a market has been held here since the twelfth century, when King Henry II granted the town its charter. *(Publisher unidentified)*

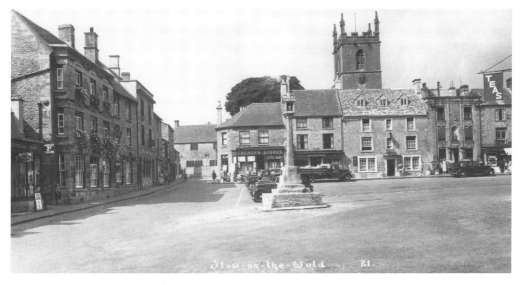

In 1476 Stow-on the-Wold ('stowe' means a holy place and 'wold' is a hill, together meaning literally holy place on the hill) was granted a charter to hold two fairs on saints' days the first on St Philip's and St James' and the second on the feast of St Edward, May and October respectively. The two dates served as the main events in the market calendar when thousands of sheep were sold at the medieval Market Cross in a single day. The cross was headless and used as a lamp standard up until 1878 when it was restored in memory of J.C. Chamberlayne of Maugersbury. This twice-yearly market event is still held, but not for the sale of sheep: its character has changed and it is now the gypsy horse fair, which maintains this unbroken tradition. *(Publisher unidentified)*

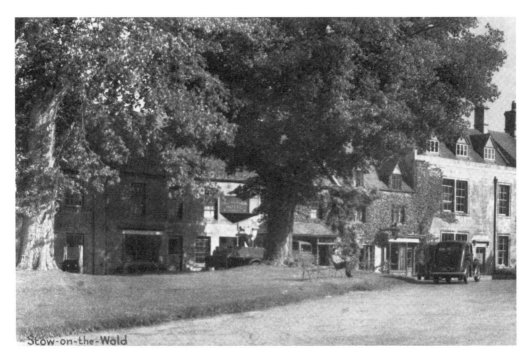

Two views of the Green at the edge of the Market Place. Protruding from beneath the trees is the Old Stocks Inn and next to it the White Hart Inn. The latest incarnation of the stocks is between the two trees, and its predecessors date back to the fifteenth century. *(Publisher unidentified)*

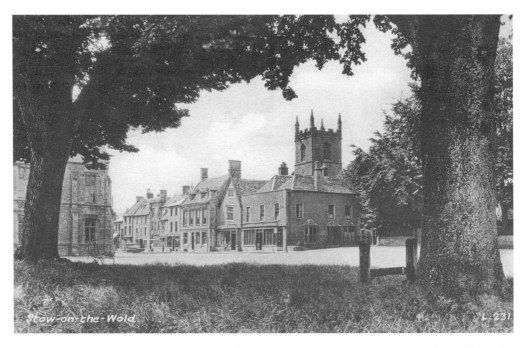

This time the view is from behind the Green looking into the Market Place. The Market Hall (on the left) was built in 1878. Other buildings in the square variously date from as early as the fifteenth and sixteenth centuries, right up to the eighteenth century. *(Walter Scott, Bradford, posted 1949)*

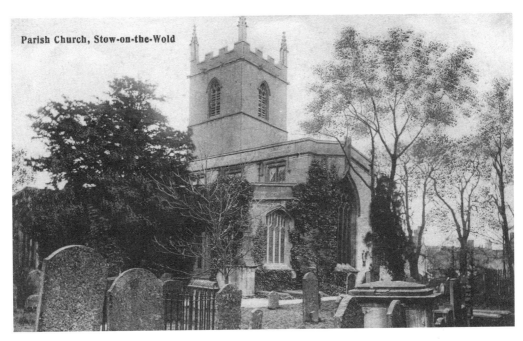

Parish Church, Stow-on-the-Wold

The parish church of St Edward witnessed the horrific aftermath of the last bloody conflict of the first English Civil War (1642–6). Over 1,000 captured Royalist prisoners were held in the church while the dead were piled up in Digbeth Street. In 1645 Charles I had stayed the night in the King's Arms before the Battle of Naseby and following this defeat he tried to rally his men in Oxford. It was at Stow in March 1646 that the Royalist army, commanded by Sir Jacob Astley making its way to Oxford to reinforce the king, was drawn into battle with the Parliamentary forces. The retreating Royalists were pushed back into the town and Astley himself was captured and sat under the Market Cross he is quoted as saying to his captors: 'Gentlemen. Ye may now sit down and play, for you have done all your worke, if you fall not out among yourselves.' *(Publisher unidentified)*

Sir Jacob Astley's men were held here inside St Edward's Church on the night of their defeat. A stone in the churchyard commemorates the dead of the battle, and in Digbeth Street stands the Royalist Hotel, a further reminder of the Civil War. The inn claims to be the oldest in England. *(Clift & Ryland, Stow)*

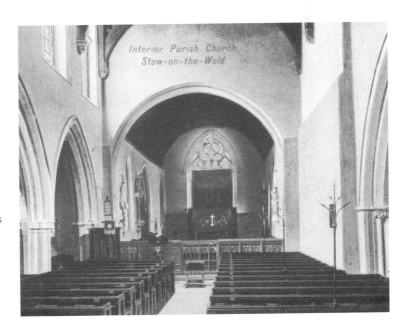

Interior Parish Church, Stow-on-the-Wold.

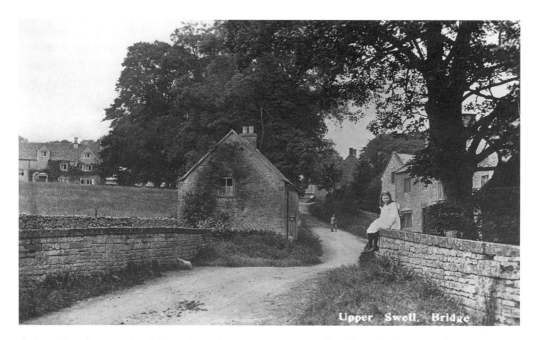

A charming photograph of the eighteenth-century Upper Swell Bridge, which crosses the River Dikler below the millpond and weir – Upper Swell village is beyond and a mile south is Lower Swell. The area has incredible antiquity with tumuli, long barrows and the remains of a Roman villa nearby. *(Publisher unidentified)*

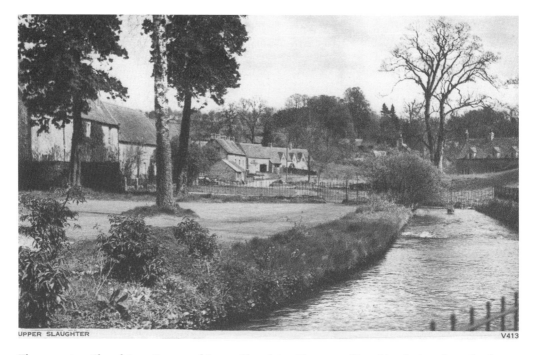

There are two Slaughters: Upper and Lower Slaughter. The name Slaughter derives from the Saxon English word 'Slohtre', which loosely translated means muddy place. The village with its church and manor house was perhaps a muddy place at one time – especially since the River Eye practically encircles the whole settlement. *(Photochrom Co. Ltd., Graphic Studios – Tunbridge Wells – Kent)*

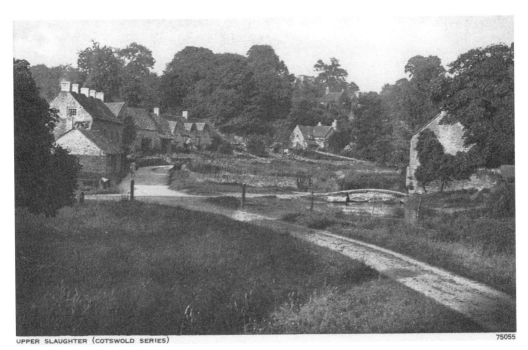

UPPER SLAUGHTER (COTSWOLD SERIES) 75055

Upper Slaughter again. The road from the Anglican Church of St Peter and the village square descends abruptly to a ford. Sometimes called Slaughter Brook, the River Eye is little more than a stream when it enters into the village from the north-west. *(Photochrom Co. Ltd., London & Tunbridge Wells)*

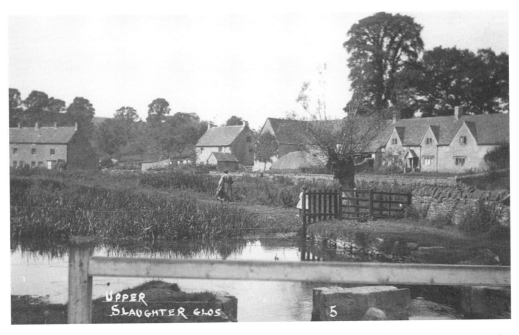

The River Eye as it turns to flow for half a mile in a south-easterly direction. The river flows around the grounds of the late Tudor Manor House, now a hotel, on its way to Lower Slaughter. It feeds water into the millpond at Upper Slaughter and again at Lower Slaughter's millpond on its short journey between the two villages. *(Photochrom Co. Ltd., Graphic Studios – Tunbridge Wells – Kent)*

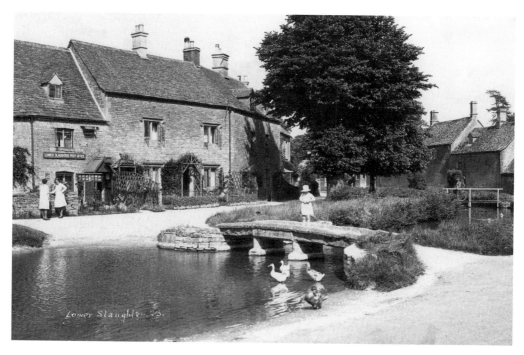

An enchanting scene filled with the magic of the Cotswolds: after flowing down from Becky Hill, the River Eye is forded immediately below Lower Slaughter's mill; a rustic stone bridge is provided for those on foot. *(G. East, Photographer, Lower Slaughter)*

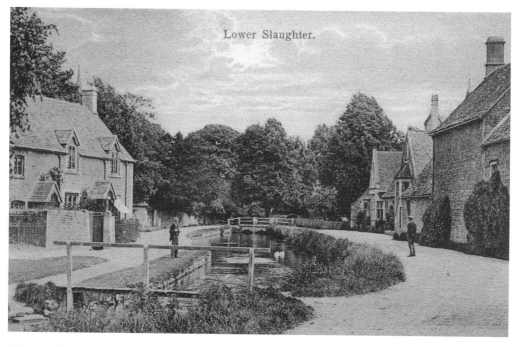

A few yards further along, downstream from the ford and footbridge, we look towards the village in the same direction as the previous card . . . *(Clift & Ryland, Stow)*

. . . and looking back from the road bridge, which was in the distance in the previous card. *(G. East, Photographer, Lower Slaughter)*

The River Eye alongside the footpath leaving the village. On the far left is the road from Copse Hill. *(G. East, Photographer, Lower Slaughter)*

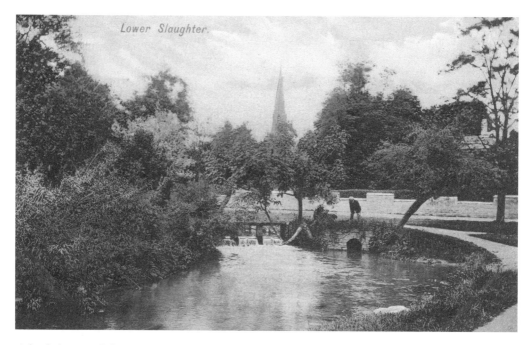

A final glimpse of the River Eye as it turns out of Lower Slaughter village to continue its journey in a south-easterly direction to join the River Dikler east of Bourton-on-the-Water. In the background is the spire of St Mary's Church. *(Clift & Ryland, Stow, posted 1905)*

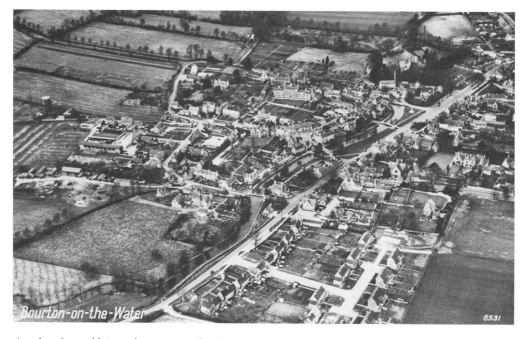

Another Cotswold river, the River Windrush, flows in a south-easterly direction through Bourton and it is joined by the Dikler a mile outside the village. As this aerial view shows, Bourton is perfectly dissected by the Windrush but five ornamental bridges join its two halves. Excluding the A429 Fosse Way crossing, Bourton-on-the-Water has in total seven bridges crossing the Windrush, which undoubtedly adds weight to its alternative title: 'the Venice of the Cotswolds'. *(Photo-Precision Ltd., St. Albans)*

Bourton-on-the-Water.

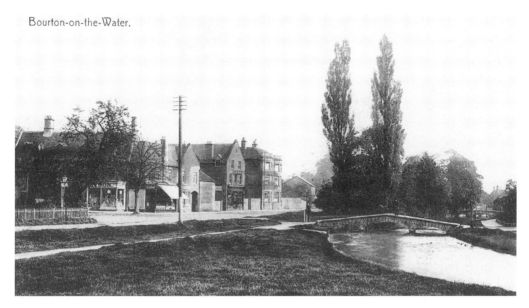

Bourton-on-the-Water was denied the status of a town by Evesham Abbey and has remained a large village from the Middle Ages onwards. Geographically it is ideally placed as a natural capital of the Cotswolds. Bourton's chief attraction is the handsome, elegantly channelled and bridged course of the Windrush. Here we see two of Bourton-on-the Water's upper bridges; firstly, looking at High Bridge down and along the High Street from Mill Bridge and Sherborne Street . . . *(A. J. Powell, Stationer, High Street, Bourton-on-the-Water)*

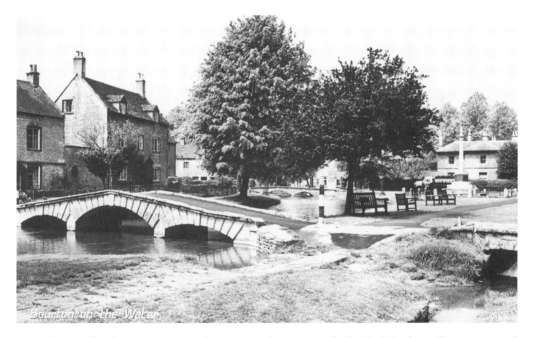

. . . and secondly, this scene is from the opposite direction with the High Bridge, village green and war memorial in view. The village sees thousands of visitors each day during summer months, all keen to visit the numerous tourist attractions, stay at the hotels and visit the pubs and tearooms. Without exception every one of Bourton's tourist businesses offer the very best in Cotswold service and hospitality, making the village one of the most desirable tourist destinations in the area. *(Photo-Precision Ltd., St. Albans)*

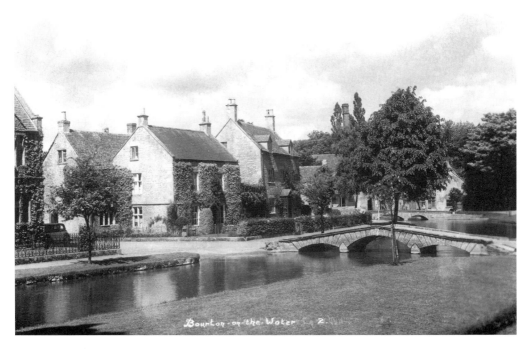

High Bridge again. Built in 1756, this ornamental footbridge crosses to a lane that leads to Victoria Street which houses more of Bourton's small shops, hotels and restaurants. *(Publisher unidentified)*

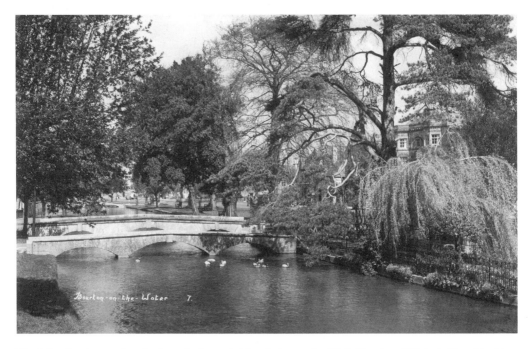

The following two postcards show the lower bridges between the High Street and Victoria Street looking upstream. The nearest bridge is New Bridge, built at the turn of the twentieth century for people on foot, and the furthest away is Paynes Bridge built in 1776 for vehicles. *(Publisher unidentified)*

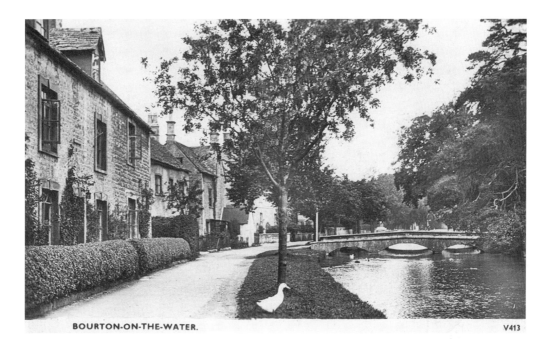

BOURTON-ON-THE-WATER. V413

A view of the same bridges as in the previous card, and more of the buildings on the riverside. Here we see further shops, restaurants and pubs; beside the bridge is the Kingsbridge Inn. The duck on the bank of the river seems undecided about taking the plunge. *(Photochrom Co. Ltd., Tunbridge Wells)*

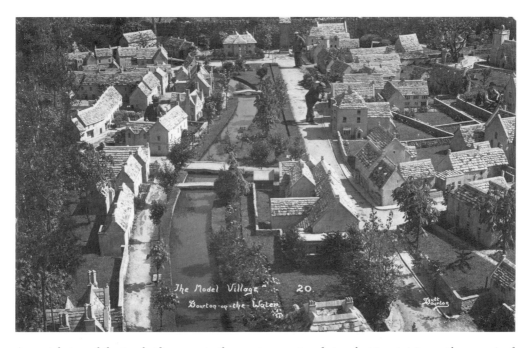

An aerial view of the two bridges seen in the previous postcard view, but in miniature – the scene is of the model village of Bourton-on-the Water built in the grounds of the Old New Inn. Bourton's sixth ornamental bridge – counting downstream from entering the village – is across the road from this former coaching inn. *(Publisher unidentified)*

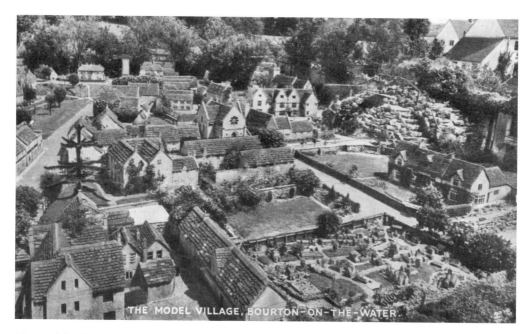

The model village, constructed in 1937 and built of Cotswold stone, is an attraction for visitors and guests to the inn. Naturally, the model of the village includes a model of the Old New Inn itself, its garden and the model! *(Publisher unidentified)*

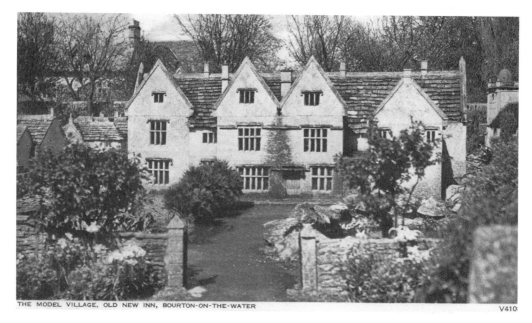

The modelled building here is of the Manor in Station Road, one of the village's finest houses. Bourton-on-the-Water has always embraced tourism and appeals to its visitors with a range of attractions: the model village, a collection of old vehicles in the Motoring Museum and Toy Collection (the old mill), a model railway, the Dragonfly Maze, a perfumery, a pottery and nature reserves. On the edge of the village, before the Windrush flows underneath one final bridge in Marsh Lane, is Birdland, an unusual and exotic collection of birds including flamingos and penguins, in a riverside setting. *(Photochrom Co. Ltd., Graphic Studios – Tunbridge Wells – Kent)*

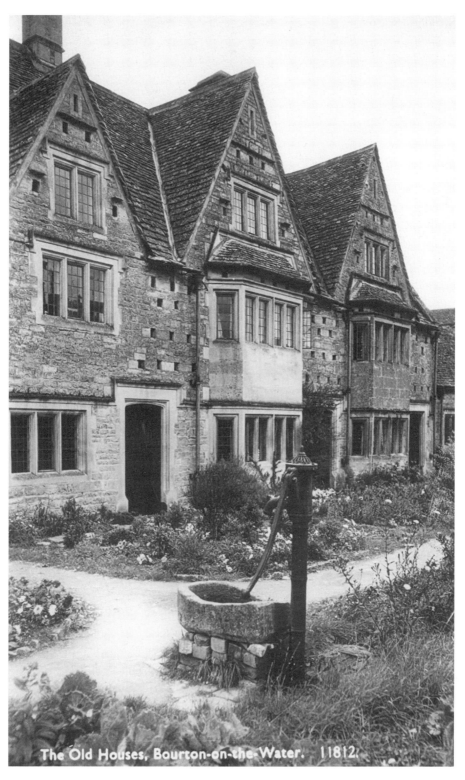

The Old Houses, Bourton-on-the-Water. 11812.

No longer in miniature, perhaps this view is typical of Bourton-on-the-Water and of the Cotswolds in general. *(Publisher unidentified)*

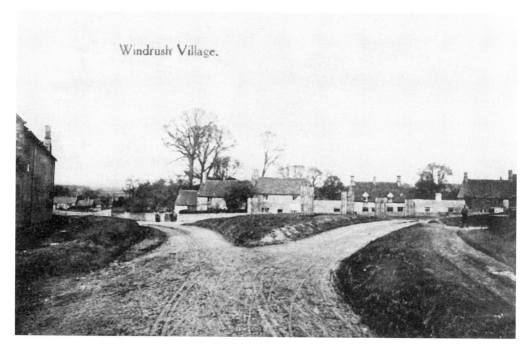

On leaving Bourton-on-the-Water, the River Windrush meanders on a 5-mile journey to the village of Windrush. The Sherborne road is on the left of the triangular green; to the right is a road to Little Barrington. *(Publisher unidentified)*

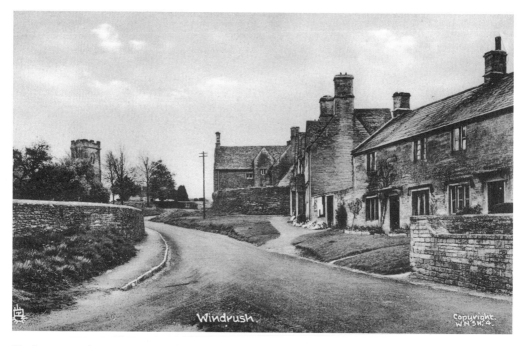

The houses on the Green are overlooked by the village's parish church, St Peter's, which has a splendid ornate Norman south doorway decorated with elaborate carvings. Equally elaborate are the decorated eighteenth-century chest tombs in the churchyard. Windrush village is overlooked by an ancient Iron Age hill fort at Camp Barn. *(Publisher unidentified)*

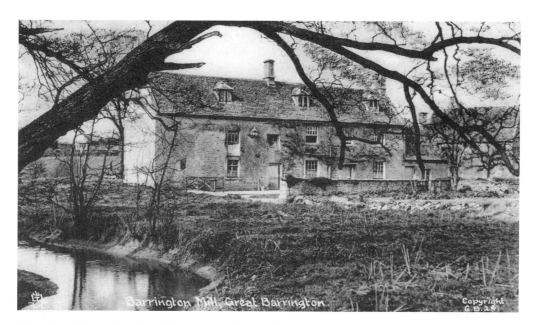

Almost equidistant from Great Barrington and its neighbouring village Little Barrington on the southern bank of the river, this mill was once one of many that stood alongside the Windrush. Used for milling flour or producing woven fabrics from wool, mills were the powerhouses of industry in the Windrush Valley. The water to drive this mill is taken from a higher reach of the river and is channelled through a leat to the waterwheel, in this case over a distance of half a mile to the mill. *(Publisher unidentified)*

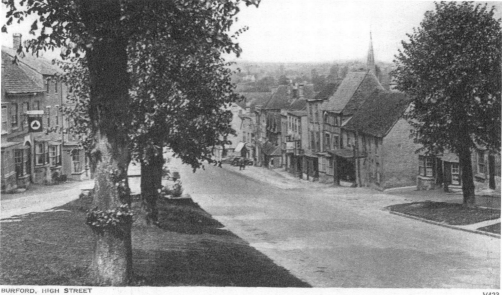

The steep High Street at Burford descends through this Oxfordshire Cotswolds town to the ancient river bridge crossing over the River Windrush. Always a busy route, it is today's A361 through the town, and at one time was an important posting stop between Oxford and the Cotswolds. Many of the buildings in this picturesque town date from the seventeenth and eighteenth centuries and reflect the town's prosperity from wool, and the quarrying of local stone used for buildings in Oxford and Blenheim Palace. *(Photochrom Co. Ltd., Graphic Studios – Tunbridge Wells – Kent)*

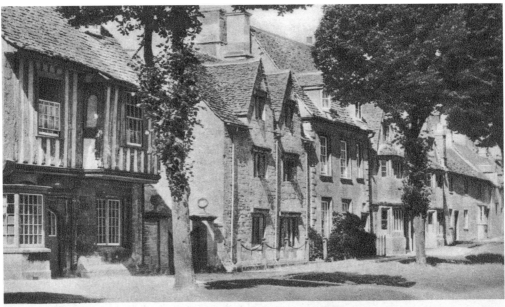

DOMESTIC ARCHITECTURE, BURFORD.

These buildings are typical of many in Burford. Despite the now busy High Street, blocked with traffic, Sheep Street has remained quiet and tranquil and unchanged from the time this photograph was taken. *(Publisher unidentified)*

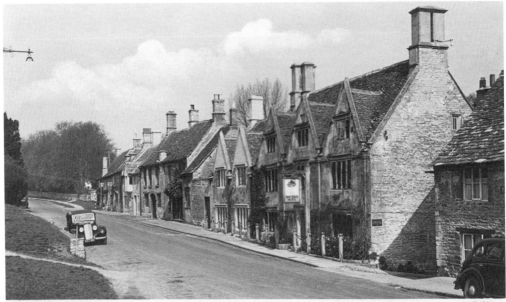

BURFORD, BAY TREE HOTEL. V3101

Also in Sheep Street, across the road from the private dwellings shown in the previous view, is the Bay Tree Hotel, a building dating back to the sixteenth century. An award-winning hotel, it retains many of its period features including wood panelling and inglenook fireplaces. Further down Sheep Street and totally in keeping with the name of the street is the Lamb Inn. Showing the same sign as in this postcard view, the building, which also extends into Tanners Lane, was originally weavers' cottages possibly dating back to the mid-fifteenth century. It is also an award-winning inn. *(Photochrom Co. Ltd., Graphic Studios – Tunbridge Wells – Kent)*

A view of the sweeping Cotswold countryside to the west of Chipping Norton. The word 'Chipping' means market, and is key to the town's origins as an Oxfordshire wool market. The town, however, was quite industrialised – there was an iron foundry, brewery and maltings in the town. Other industries included glove-making, tanning, and most famously a tweed mill. *(Valentine's 'Bromotype' Series)*

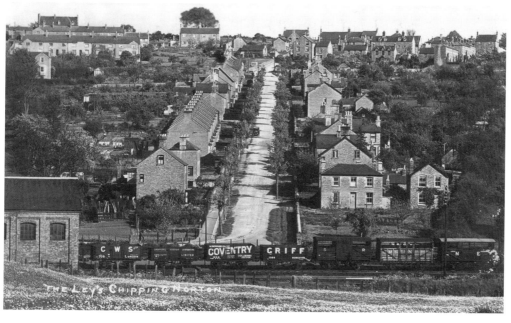

The Leys, Chipping Norton, with housing for workers from the nearby Bliss Mill which used to weave tweed. The mill has now been converted into flats and the road is part of a residential district of the town. The Leys joins Station Road, which led to the town's station on the former GWR OW&WR branch from Kingham, later the Banbury and Cheltenham Direct Railway. Chipping Norton lost its passenger service in 1962 and the line closed completely in 1964. *(Publisher unidentified)*

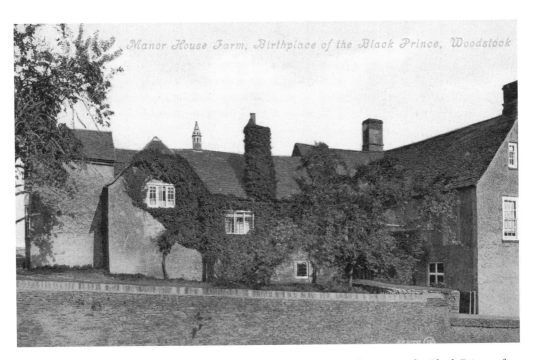

The birthplace of Edward of Woodstock, Prince of Aquitaine better known as the Black Prince after his death (1330–76), is recorded as being Woodstock Palace. The palace had fallen into ruins by the time Blenheim was built and it was finally demolished in 1720. The site is close to Vanbrugh's great bridge spanning the ornamental lakes in the grounds of Blenheim Park. Manor House Farm in Old Woodstock, formerly Praunce's Place, dates from the Middle Ages, but its association with the Black Prince other than its proximity to the palace is uncertain. The farm on Manor Road, overlooking the River Glyme, is close to another building celebrating the prince, the Black Prince pub. *(Valentine's Co Ltd., Dundee & London)*

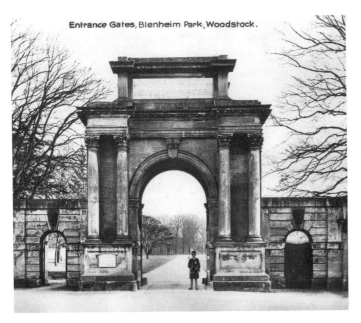

Woodstock and Blenheim are at the very tip of the eastern edge of the Oxfordshire Cotswolds AONB. The Triumphal Arch at Park Street in Woodstock is the entrance to Blenheim Palace – it is a celebration of baroque magnificence in Cotswold stone, much of which was mined at Taynton near Burford.
(Publisher unidentified)

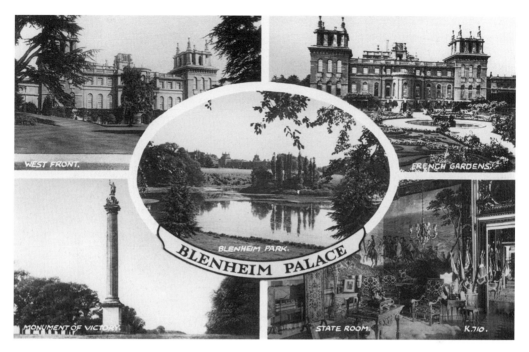

Blenheim Palace was built as a gift from Queen Anne to John Churchill, 1st Duke of Marlborough, (1650–1722) in appreciation for his service to the country and his victory at the battle of Blenheim in 1704 during the European War of Spanish Succession. *(Valentine's Co Ltd., Dundee & London)*

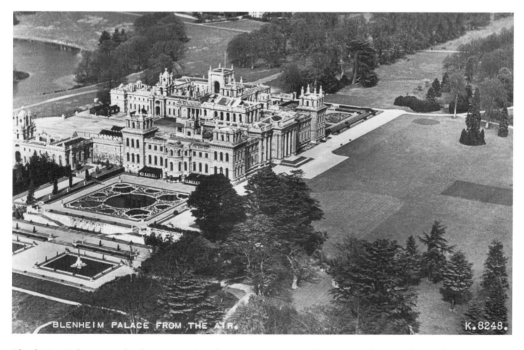

Blenheim Palace was built as a national monument as well as a residence. The architect was Sir John Vanbrugh, and Nicholas Hawksmoor skilfully executed his designs between 1705 and 1722. *(Publisher unidentified)*

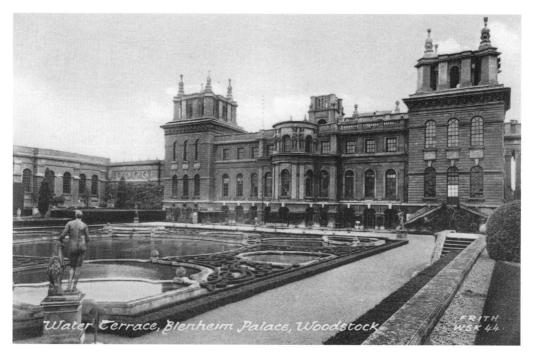

The water terrace and formal gardens which flank the house. Earlier Baroque gardens were swept away when Capability Brown landscaped the remaining 2,000 acres of parkland. *(F. Frith & Co. Ltd., Reigate)*

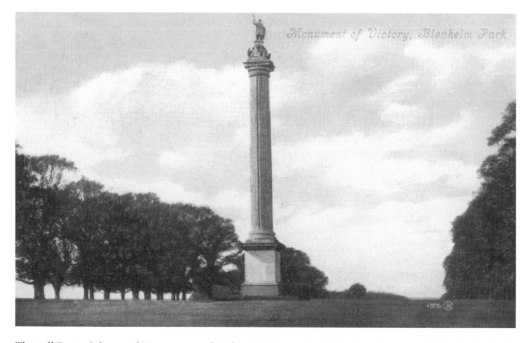

The tall Doric Column of Victory, completed in 1730, stands in the Great Avenue at Blenheim Park, topped with a statue of the first duke. Blenheim Palace was famously the birthplace of soldier, statesman and wartime Prime Minister Winston Churchill (1874–1965). *(Valentine's Co Ltd., Dundee & London)*

4

Stroud & the Five Valleys

'Stroud is chiefly famous for its woollen manufactories. The Stroud Valley above Brimscombe is very pretty and picturesque.'
(*Littlebury's Cyclist's Guide, Route Book for the West Midlands walking the cities of Worcester, Hereford & Gloucester,* each a centre for the cyclist, together with copious notes on the state of roads, dangerous hills etc., and objects of interest en route. Harold Freeman MA, Oriel College Oxford, 1898)

From Birdlip village (Chapter 2) the Cotswold Way takes a southerly course to Kimsbury Iron Age hill fort and Painswick Beacon, from where it descends into the village of Painswick. Then, taking an easterly course, the path joins the Golden Valley and the Stroudwater Canal at Ryeford, where it resumes its southerly climb to the Cotswold Edge through Selsley Common and Pen Hill.

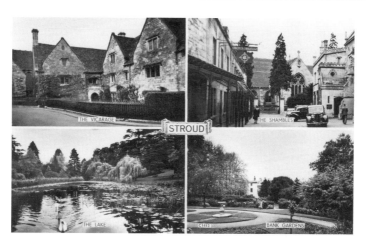

The Frome Valley, also known as the Golden Valley, has four other valleys joining it. The Toadsmoor, Slad and Painswick join the Golden Valley from the north, and the fourth, Nailsworth Valley, joins the Frome Valley from the south. The multi-view card shows some of the attractions of Stroud, the principal woollen-cloth town of the area. The valleys supplied the water to drive the mill wheels, and the wool industries needed a copious quantity to wash and dye wool and cloth. After the rich clothiers built their mills and factories, this in turn attracted the railways, expanded the roads, villages and towns, and generally brought the industrial age to these Cotswold valleys. However, the hillsides managed to retain their rural beauty and did not succumb to the influences of urbanisation so apparent in the bottom of the valleys. *(Lewis & Godfrey, Ltd., Stroud)*

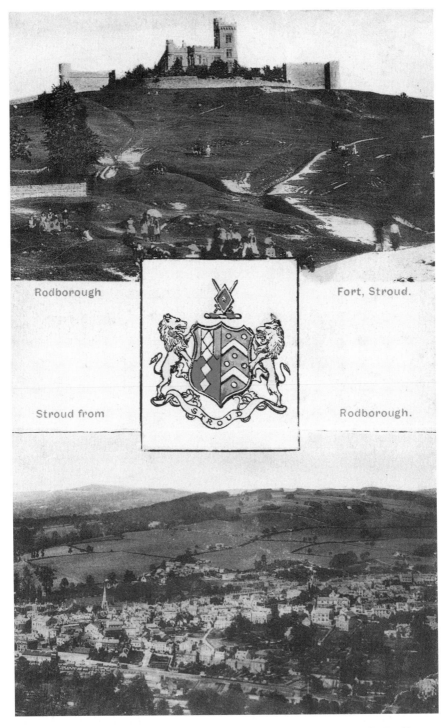

The parish of Rodborough encompasses the slopes of Rodborough Hill, which offers an impressive view of Stroud across the Frome Valley to the north-east. Nailsworth Valley to the west forms the boundary to the common, and the land belongs to the National Trust, having been donated in 1937 by Thomas Bainbrigge Fletcher (1878–1950). *(Lewis & Godfrey, Ltd., Stroud)*

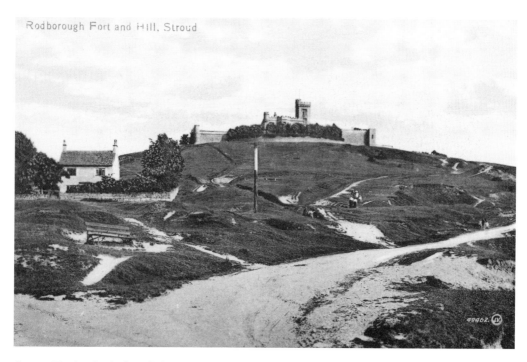

Rodborough Fort and Hill, Stroud

George Hawker built the inhabited folly Rodborough Fort, originally known as Fort George, in about 1764. Subsequently, Joseph Grazebrook (1750–1843), a Stroud banker and partner in a brewery, owned it from 1802 to 1842, and Alexander Halcombe rebuilt it after 1868. The building remains a private residence. *('Valentine's Series' Valentine & Sons Ltd., Dundee & London)*

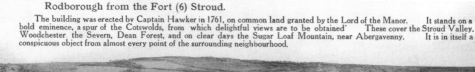

Rodborough from the Fort (6) Stroud.

The building was erected by Captain Hawker in 1761, on common land granted by the Lord of the Manor. It stands on a bold eminence, a spur of the Cotswolds, from which delightful views are to be obtained. These cover the Stroud Valley, Woodchester, the Severn, Dean Forest, and on clear days the Sugar Loaf Mountain, near Abergavenny. It is in itself a conspicuous object from almost every point of the surrounding neighbourhood.

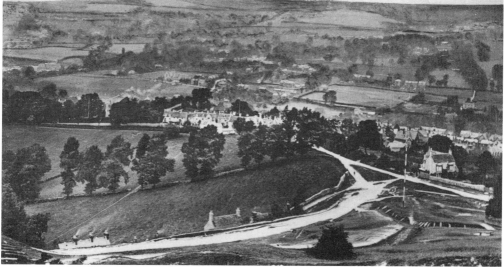

As the caption on the postcard aptly says, 'the fort is a conspicuous object visible from the surrounding neighbourhood'. *('Famous Series' Tomkins & Barrett, Swindon)*

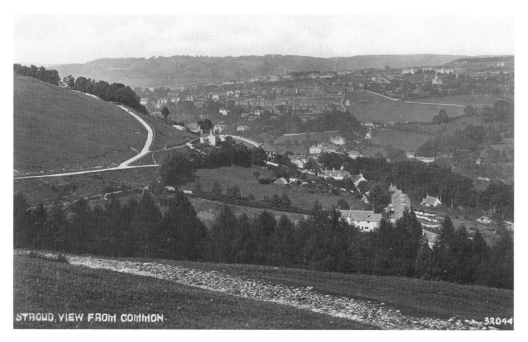

Stroud became the centre of cloth manufacture in the Cotswolds, and doubled in size during the nineteenth century when weaving became part of a continuous manufacturing process in the newly built mills. Direct competition with the mills of Lancashire, Yorkshire and Europe eventually brought terminal decline and mills became redundant. Stroud's townscape has few of the attractions that other less industrialised Cotswolds towns have to offer; especially those towns and villages spared the ravages of industry and subsequent urban decline. *(Publisher unidentified)*

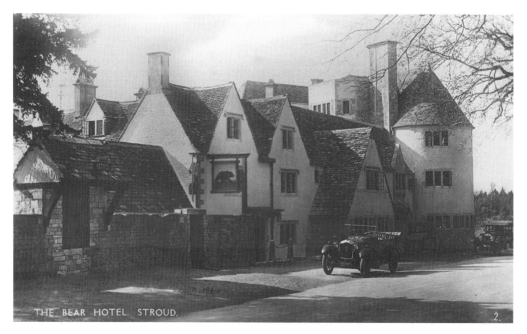

The Bear at Rodborough opened by 1751 on the common beside the Stroud–Cirencester turnpike. The road followed an ancient trackway over the high ground between the Nailsworth and Golden Valleys. *(Publisher unidentified)*

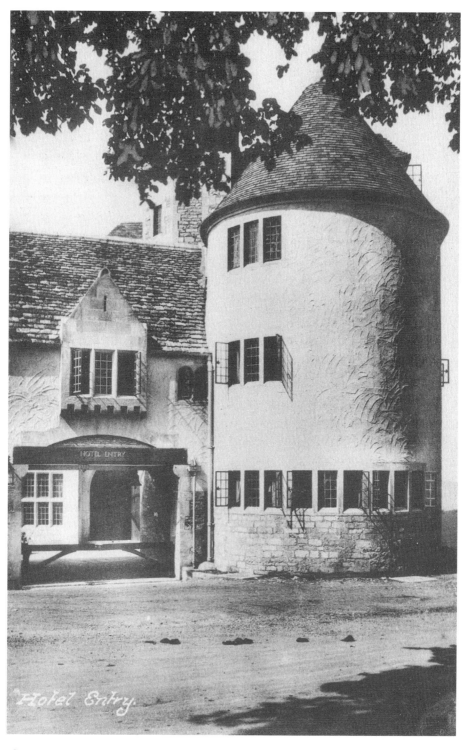

The Bear Hotel, as it came to be known, after the former inn was rebuilt in the 1920s.
The entrance to the hotel remains very much unaltered from that time. Despite industry
and urbanisation in the nearby valleys, the views from the surrounding uplands around
Rodborough are dramatic and impressive. *(R.H.S. Stroud)*

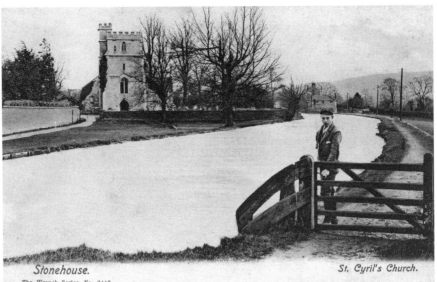

Stonehouse. St. Cyril's Church.

The Wrench Series. No. 3448

The Cotswold Way
after passing through
Painswick (46½ miles)
(see page 95) resumes its
course along the Cotswold
Edge, and largely avoids an
incursion into the Stroud
valleys. Passing Edge,
Randwick and Westrip
it emerges at the mouth
of the Golden Valley
at Ryeford (56 miles),
between Stonehouse and
Stroud.

Stonehouse is a small mill town at the mouth of the Golden Valley. This scene shows St Cyril's Church from the Stroudwater Canal between Nutshell Bridge and another small bridge beside the canal basin called the Ocean, and it is easily identifiable today. The canal is derelict, but still in water over much of its length, awaiting restoration and reinstatement as a Cotswold Waterway. Both built in the 1720s, the Stroudwater Navigation linked with the Thames & Severn Canal to provide a through-route between the Severn and Thames. *(The 'Wrench' Series)*

The visit of a peripatetic photographer to the town seems to have excited a lot of interest, as a crowd has gathered in the upper High Street. The photograph was taken close to the corner of Elm Road with the High Street. The Monkey Puzzle tree has been cut down, but the trees lining the High Street remain and have matured. The buildings seen in the distance are still there today; a bank, teashops, cafés, and even a fishing tackle shop. *(The 'Wrench' Series)*

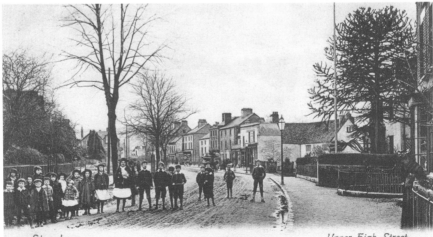

Stonehouse. Upper High Street.

The Wrench Series. No. 3445

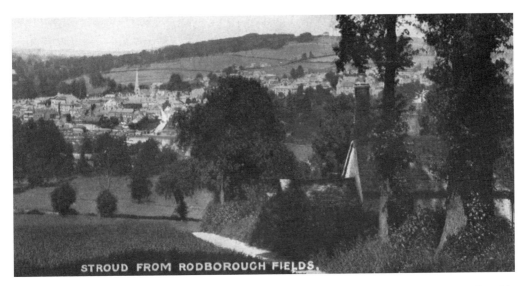

Despite more roads and housing developments, the descent from the lane above Rodborough Fields towards the banks of the River Frome and Stroud is, if anything, an agreeable and pleasant pastoral walk. The spire of the parish church of St Laurence, prominent on the Stroud skyline, is still visible from this same spot, as are many of the old buildings in the town centre. By the eighteenth century Stroud had developed as the centre of the Cotswold cloth industry – observing the former town mills and industry from up high today bears testimony to that fact. (*Publisher unidentified*)

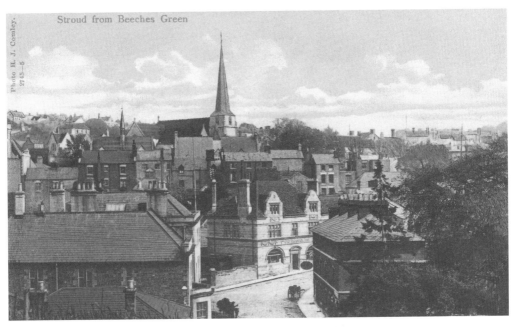

From Beeches Green we see the Old Painswick Inn (centre) and the elevated aspect of St Laurence's Church overlooking Stroud's town centre. The building immediately on the right has been lost to a road-widening scheme, which widened the A46 along Merrywalks. From the same vantage point, the scene remains relatively unchanged. Ye Old Painswick Inn, like many other pubs in the town, has closed and is no longer a hostelry, but as the old saying goes: 'there are only two things certain in life: death and taxes' . . . the two businesses that now share the building are a funeral company and accountancy and tax service. (*H.J. Comley*)

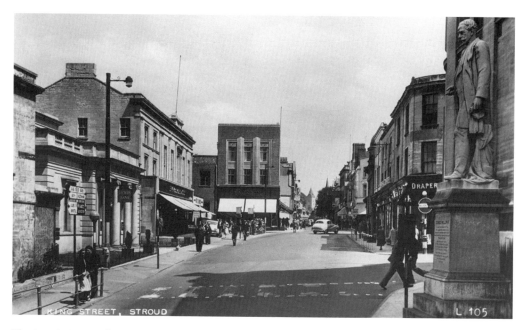

The inscription on the statue, which stands in Rowcroft at the corner of King Street, and Russell Street, honours George Holloway. It says: 'He was the founder of the Mid-Gloucester Working Men's Conservative Association Benefit Society and represented this division in Parliament from 1886 to 1892 . . .' He was a clothing manufacturer and one of the largest employers in Stroud, and he is responsible for introducing ready-to-wear clothing and sewing machines to the UK. *(Publisher unidentified)*

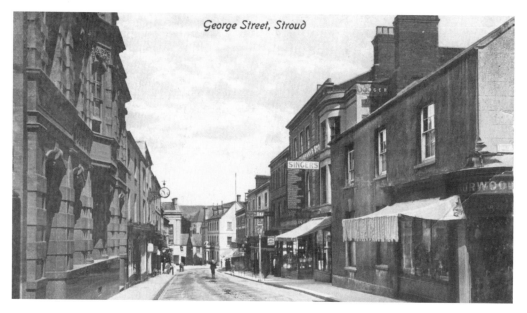

At the bottom of George Street are King Street and the High Street, Stroud's oldest inhabited areas. Stroud grew up around the High Street, which was the through-route between the village of Bisley to the north-west and Paganhill. The route took advantage of dry, high ground, as lower parts of the valley were permanently boggy and wet. King Street brought traffic to the town centre from the London turnpike road lower down in the valley. George Street was named in honour of George III's visit in 1788 and much of the street is recognisable today, although Singer sewing machines are no longer sold in the shop on the right. *(Publisher unidentified)*

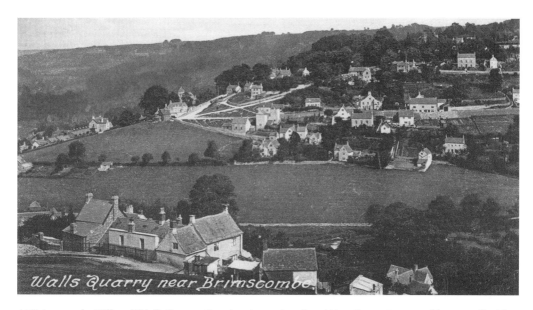

At Brimscombe Hill and Walls Quarry the view is spectacular. Attractive cottages and houses all with a view cling to narrow lanes that climb the steep hillside. In the distance are Burleigh Court, Holy Trinity Church, the junction at Roundabouts, the narrow Water Lane and Brimscombe Hill Road, which leads down to Brimscombe Port. The port was the old canal basin on the Thames & Severn Canal, alongside which most of the Brimscombe's industry was located. *(Walter Collins, High Street Stroud)*

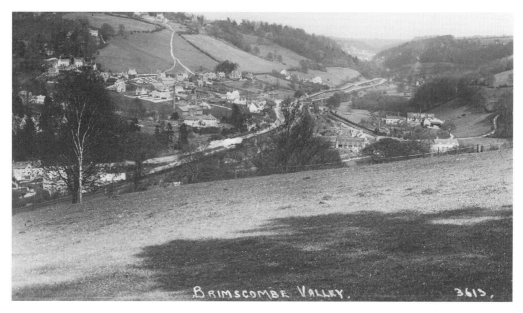

The Frome Valley or Golden Valley extends in a south-easterly direction from Stroud to enclose the villages of Thrupp and Brimscombe. Looking directly east along the valley from the National Trust-owned land at Burleigh Court, are the three modes of transport that helped develop industry in the valleys: road, railway and canal. Here the London Road, the GWR Cheltenham & Great Western Union Railway and the Thames & Severn Canal all run alongside each other. Knapp Lane crosses left to right in the middle of the view and passes under the road and railway and over the canal. The canal is now derelict and not in water, although most of its course is easily traceable. The lane then climbs out of the valley through the wooded hillside towards Hyde Hill and Burnt Ash on the Cirencester Road. *(Publisher unidentified)*

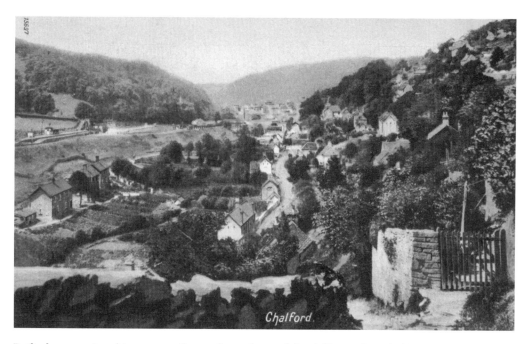

Built along a series of terraces on the northern slopes of the Golden Valley, Chalford village is a mix of eighteenth- and nineteenth-century houses, which once belonged to weavers and wealthy clothiers. The GWR Cheltenham & Great Western Union Railway and Thames & Severn Canal are on the far left across the valley. The view shows the narrow High Street running into the distance, which is little more than the width of a driveway, but very well worth exploring on foot. *(The 'Wrench' Series)*

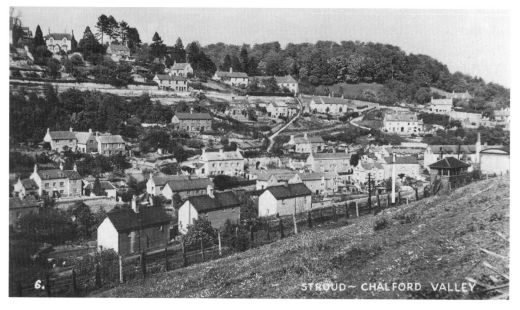

The northern slopes again seen from the opposite side of the Golden Valley and the London Road overlooking the railway. The station water tower, signal-box and signal post are on the right, guarding the approach to the station and goods yard – the railway still exists but the station, goods yard and canal are all gone. The railway is largely hidden from view nowadays, disguised by trees and woodland that has grown over the railway embankment. *(Publisher unidentified)*

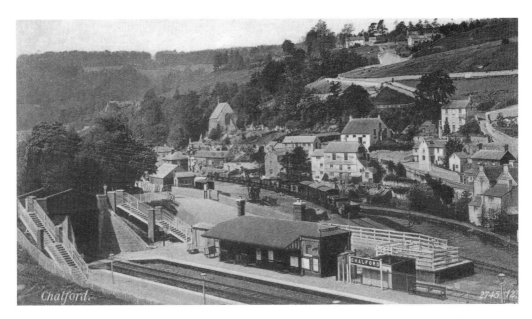

Here we look down the valley over the former GWR station at Chalford. The station opened in 1897 and closed in 1964, and housing now occupies the Old Station Close. The London Road Bridge has been replaced with a sturdier structure to take the increased traffic of the A419. The Thames & Severn Canal beyond the station declined gradually and after abandonment most of its course is little more than a trickle, although parts await restoration under the Cotswold Canals Trust's restoration project. In the middle distance is Chalford High Street. *(Publisher unidentified)*

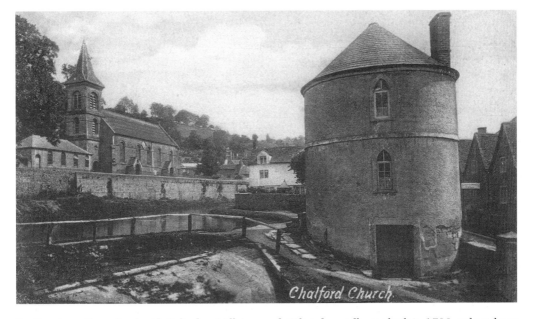

Further down the valley, beside Belvedere Mill, is a grade II listed roundhouse built in 1790 and used as a lengthman's cottage. The roundhouse – continually occupied since the canal fell derelict – is a remarkable survivor of the canal age. It is the first of five similar roundhouses that occupy the abandoned stretch of canal to Lechlade on the River Thames. Recently this small section of canal has been dredged which has restored much of this scene. Above the canal alongside the London Road is Christ Church, Chalford's parish church, built between 1724 and 1725 and extensively altered in 1840. *(F. Frith & Co. Ltd., Reigate)*

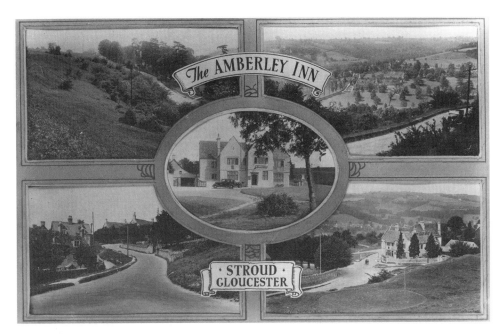

The AMBERLEY INN

STROUD · GLOUCESTER

Leaving Ebley, Selsley and the Golden Valley behind, the Cotswold Way climbs to Selsley Common above Woodchester to the east, and makes its way to Pen Hill (60 miles).

The second largest valley of the Five Valleys and (equally important industrially) is the Nailsworth Valley to the south of Stroud. Woodchester and Inchbrook lie on the valley floor overlooked by Amberley and the site of an ancient hill fort on Minchinhampton Common. *(Publisher unidentified)*

Amberley Parochial School was founded in 1836 in the same year as the Gothic-style Holy Trinity Church was built at the opposite end of the Green. The school buildings on the right date from 1888, while in the distance the Amberley Inn was built in the mid-1850s, for the benefit of tourists to the area. The inn also ran a cab service to the nearby stations at Woodchester and Nailsworth on the Stonehouse and Nailsworth Railway opened in 1867, later a branch of the Midland Railway. *(Publisher unidentified)*

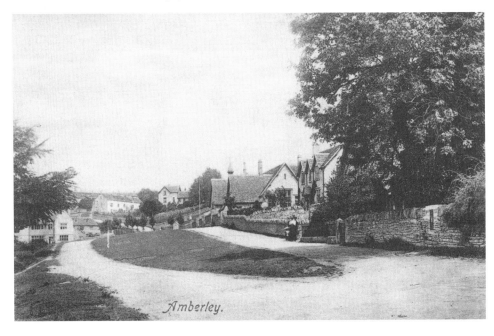

Amberley.

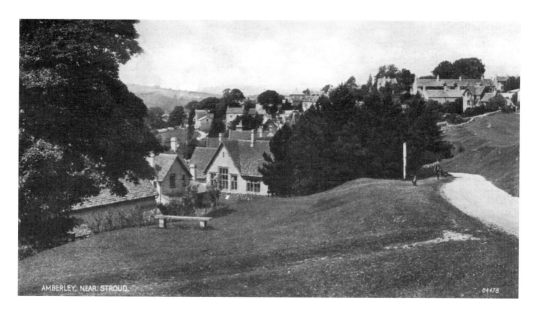

Descending Culvar Hill from Minchinhampton Common, the school building emerges on the left, as the village hillside aspect becomes more apparent. Above the village is Amberley nature reserve, which has a claim to fame as the habitat of one of Europe's largest insects, the Great Green Bush Cricket, that can grow to 5cm in length. *(Publisher unidentified)*

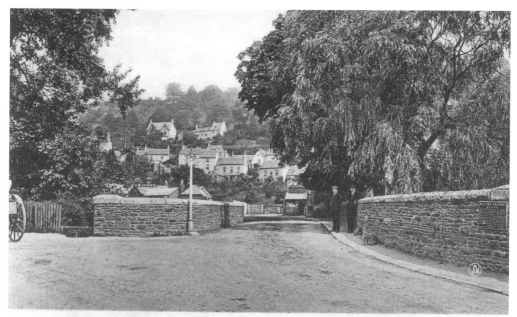

Watledge Nailsworth, near Stroud Valentines Series 49467

Nailsworth station was a quarter of a mile from the centre of the town. The Midland Railway employees are seen from Bridge Street standing against the wall of the bridge at the entrance of Station Road. Watledge is in the distance. Behind the large tree on the right is the old Railway Hotel. The fire station now occupies the site of the coal office of C.W. Jones in the station coal yard. The stream crossed by the bridge feeds the millpond at Egypt Mill. Once used for fulling, dyeing and milling animal feed, it has since been converted to a bar, restaurant and hotel. *('Valentine's Series' Valentine & Sons Ltd., Dundee & London)*

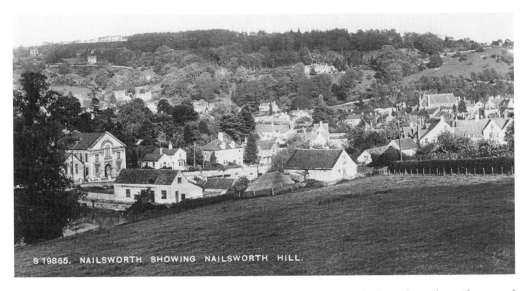

Nailsworth is situated 4 miles south of Stroud and here we see a view looking down from Shortwood Road towards the north-west. In Newmarket Road on the left is Christ Church Baptist Union chapel, and on the right is another nonconformist chapel on the Bristol Road: Nailsworth's Tabernacle Church. The hill that rises up from behind the town is Nailsworth Hill. The town derives its name from 'Naeglesleag' meaning the 'pasture of Naegl' (Saxon for nail), while 'worth' means small hamlet. The town grew because of the cloth industry and by 1892 had absorbed parts of the nearby parishes of Avening, Horsley and Minchinhampton, and included in its boundary the hamlets of Shortwood, Newmarket, Rockness and Watledge. *(Publisher unidentified)*

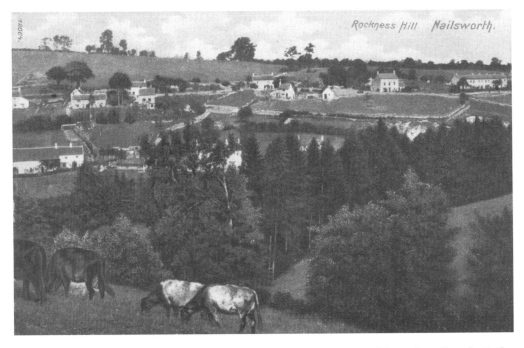

Rockness Hill and the view of Horsley Valley. Two turnpike routes emerged from the valley: the Bath–Gloucester road after 1780 and the Dursley–Bristol road, which dated from the early nineteenth century. This road passes through the village. *(The 'Wrench' Series)*

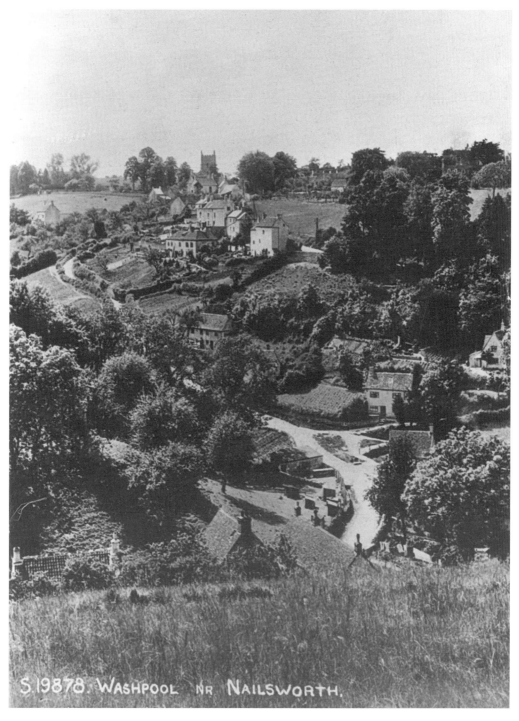

S.19878. WASHPOOL NR NAILSWORTH.

Washpool at the head of Horsley Valley and the Horsley road rising up from the valley floor. The church of St Martin is at the top of Horsley village in the distance. The village takes its name from the old English 'Horse Lega' (meaning 'place of horses'). The head and top of the valley is part of an ancient Cotswold ridgeway. *(Publisher unidentified)*

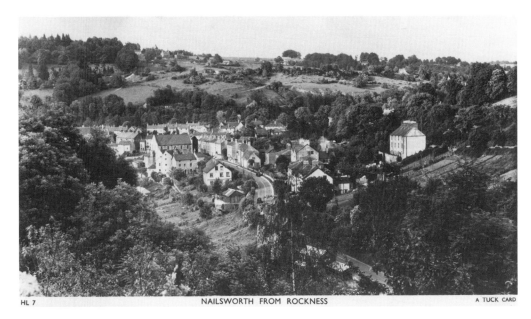

HL 7 NAILSWORTH FROM ROCKNESS A TUCK CARD

Nailsworth seen from Rockness Hill. The Old Bristol Road below enters the town after crossing Rockness Hill on its way from the Horsley Valley. The Town Hall is the largest building in the group on the left. The snaking Ladder Road makes its way up the north-eastern slope of Nailsworth Hill in the distance. *(Raphael Tuck & Sons, Ltd.)*

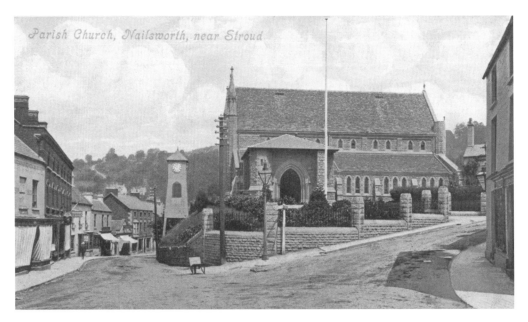

Parish Church, Nailsworth, near Stroud

St George's is Nailsworth's parish church, situated at the junction of Church Street and Fountain Street, looking on from the Bath Road. St George's Anglican Church was a much later addition to Nailsworth's religious buildings, built in comparatively recent times from 1900, after the Church of England congregation grew sufficiently large to merit a new church. The town's traditions had tended to religious nonconformity and other denominations were in the minority. The clock tower in this photograph has gone, but another clock tower has taken its place at the roundabout between Bridge Street, George Street and Spring Hill. *('Valentine's Series' Valentine & Sons Ltd., Dundee & London)*

Nailsworth is nestled at the convergence of two deep valleys, the Avening to the south-west and the Horsley to the south-east. The Miry Brook in the Newmarket Valley, the Avening Stream and the Horsley Stream all come together in the town to form the Nailsworth Stream. The town developed on the drier slopes while the valley bottoms remained marshy. By the seventeenth century the mills and dye houses of the cloth industry gradually occupied the valley floor, which was also the location of the Nailsworth Brewery, and malt houses can be seen on the right of the picture. *(F. Frith & Co. Ltd., Reigate)*

The Devil's Elbow in the Avening Valley, a 180-degree hairpin bend on Pensile Road. The scene has not altered to this day. The roads through the valleys often took a course that followed the curvature of the valley sides as the bottoms of the valleys were often marshy and waterlogged, and therefore best avoided. It was not until the development of mills that required waterpower that the collection of water into millponds had the added effect of draining marshy areas in the valleys. Turnpike roads were soon built in the dry valley bottoms to serve these new cloth mills. The old roads remained to serve expanding housing, or as an alternative to paying toll charges on the turnpikes and for the transportation of livestock between farms. Today they are valuable amenities for walkers, cyclists and local residents. *(Unidentified)*

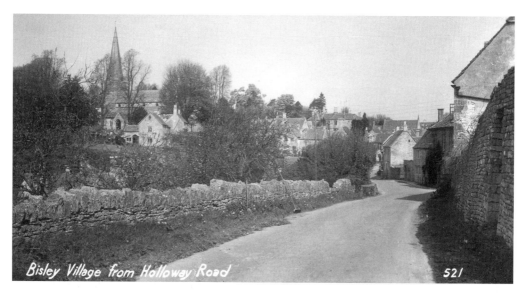

Above the Toadsmoor Valley north-east of Stroud is the pretty village of Bisley, and at its centre is the church of All Saints' with its impressive spire. Seen here from Holloway Road, it dates from the thirteenth century, while the chancel and tower are medieval. Victorian rebuilding has extensively altered the remainder. A local legend associated with the church tells how Henry VIII left his nine-year-old daughter Elizabeth at Overcourt hunting lodge in Bisley to escape the plague. As the story goes, the princess unfortunately died and fearing the consequences, her guardians substituted another child of similar appearance – however the nearest likeness was a boy. King Henry was apparently duped and accepted Elizabeth's male impostor as his daughter and heir, later crowned Queen Elizabeth I and, though fearful of being discovered, the Virgin Queen reigned England for the rest of her/his life. *(Publisher unidentified)*

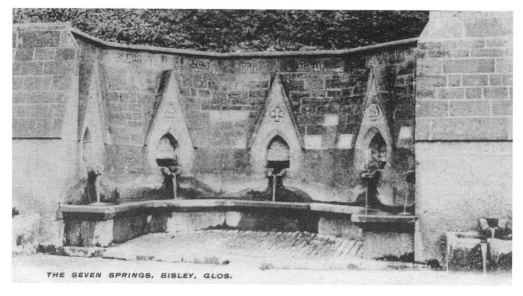

Beneath the church in Wells Road are the Seven Springs, a Victorian ornamental Gothic structure that surmounts natural springs. Five semicircular stone arches feed the water onto a stone shelf, and from the sides emerge two more springs that feed into stone troughs. Ordinary stone troughs next to the structure also catch the spring water – once used by the villagers as their primary water supply and for watering livestock. A well-dressing ceremony on Ascension Day has become an annual local event. *(F. Clarke, Bisley)*

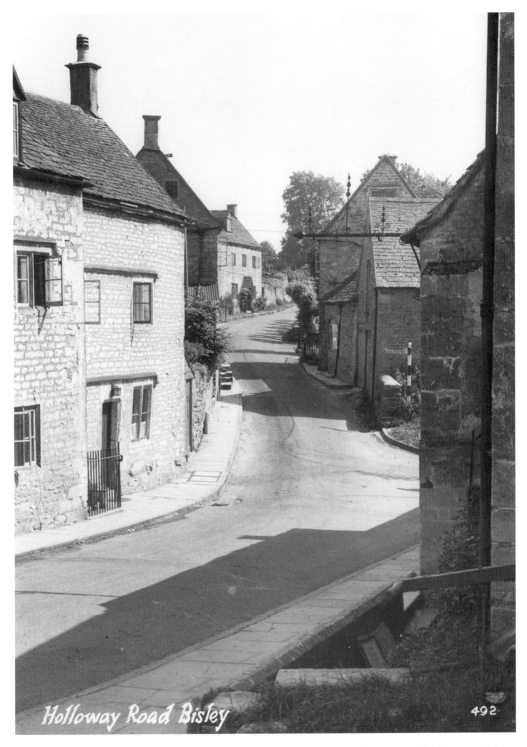

Holloway Road Bisley

492

Here we see fine old honey-coloured Cotswold stone buildings along Holloway Road looking south from the corner of the High Street and Wells Road. Every cottage, house, shop, pub and garden adds to the charm of this perfect Cotswold village. *(Publisher unidentified)*

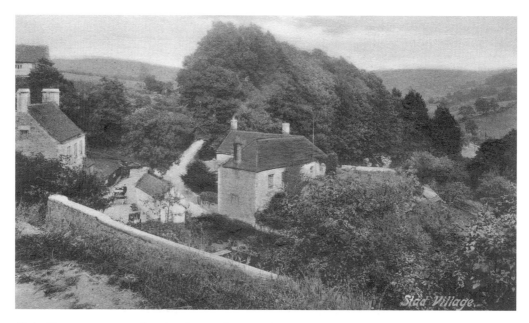

Slad village was immortalised as the rural setting for poet and author Laurie Lee's *Cider with Rosie* (1959). The Slad Valley extends northwards from Stroud, bisected by the Cheltenham road (the B4070). Overlooking the picturesque valley is Holy Trinity Church, opened in 1834, and Laurie Lee (1914–97) is buried in the churchyard there. Across the road is the Woolpack, a traditional roadside pub with an equally impressive view over the village and the valley. *(Publisher unidentified)*

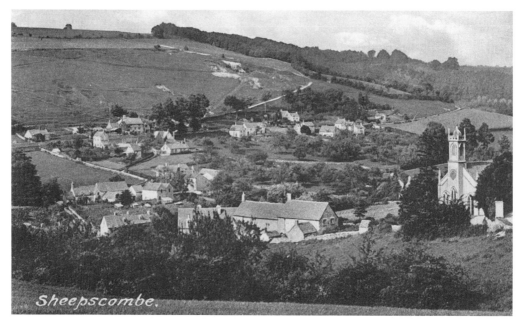

Sheepscombe is a scattered village on the slopes of a wooded valley that joins with the Painswick Valley. The village church is St John the Apostle (built 1819–20) and it has an unusual small tower and ogee roof held by corner pinnacles. The village was in existence in the thirteenth century and grew around clothmaking. The Butchers Arms pub is in the valley, and the village is predominately a rural retreat. *(Publisher unidentified)*

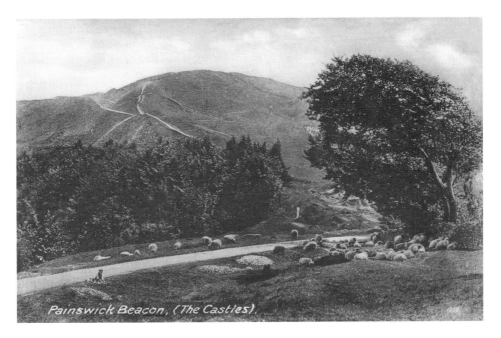

Painswick Beacon, (The Castles).

Dating from 500 BC, Kimsbury hill fort at Painswick Beacon is a strategically placed Iron Age settlement high on the Cotswold Edge. With well-preserved ramparts and defensives ditches, the so-called castles are on the eastern edge of the fort above the B4073 road. *(H.M. Strange, The Post Office, Painswick)*

Painswick Beacon offers exceptional views of the Severn Vale to the west, and sits prominently above the Painswick Valley. *(H.M. Strange, The Post Office, Painswick)*

Two long-distance paths, the Cotswold Way (46½ miles) and the Wysis Way, meet at the hill fort and beacon. The Cotswold Way then heads south, skirting the Five Valleys to cross the Golden Valley near Stonehouse (see page 76).

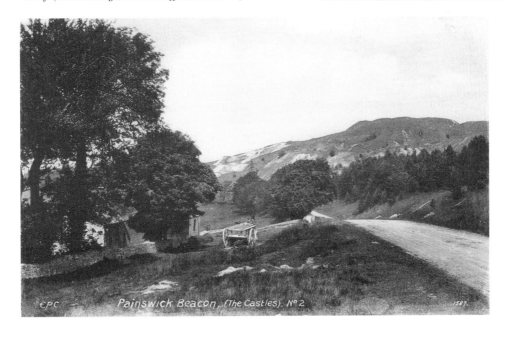

Painswick Beacon, (The Castles). No 2

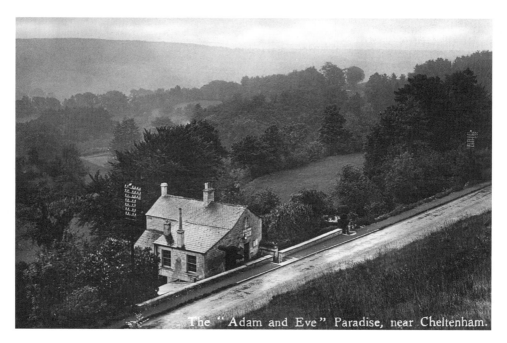

The " Adam and Eve " Paradise, near Cheltenham.

Local folklore holds that during the English Civil War Royalist forces and the king were encamped to the north of Painswick, and that King Charles visited the beacon. On seeing the beautiful valley, he is reputed to have said 'This must be Paradise', and Paradise was adopted as the name of the hamlet and valley ever since. The name of the former inn on the Paradise Road (A46) was the Adam & Eve, though today it is a private dwelling. *(The 'Cheltonia' Series)*

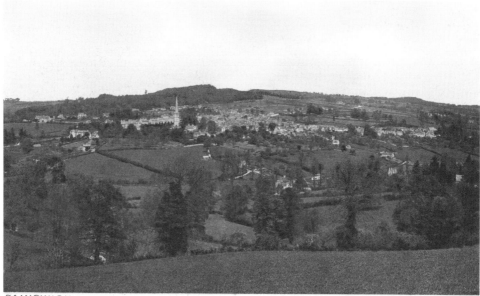

PAINSWICK.

Painswick is a small town at the head of a connecting valley 3 miles to the north of Stroud and the Golden Valley. The distant spire belongs to St Mary's Church, photographed from the southern edge of the valley beside Yokehouse Lane. *(Publisher unidentified)*

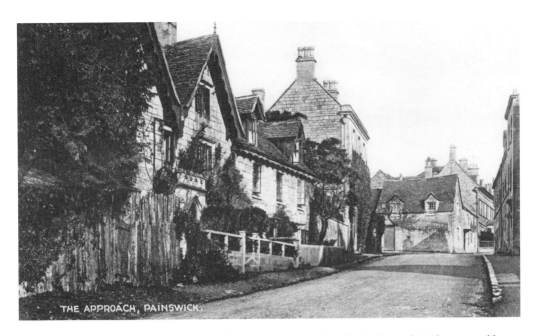

The approach to Painswick from the south by New Street and the A46. On the right is the county library. Unlike the honey-coloured Cotswold stone elsewhere in the district, the buildings in the town are of a much greyer stone, which comes from Painswick Beacon quarry. Unlike some Cotswold villages and towns, there has been little or no building development in the town centre to distract from its splendour, and the town's unspoilt appearance justifies its claim to the title of the 'Queen of the Cotswolds'. *(Publisher unidentified)*

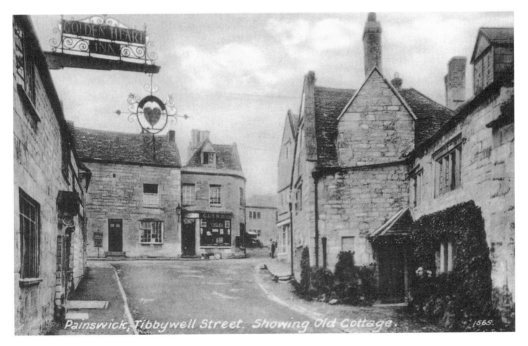

A view towards the crossroads between Friday Street and St Mary's Street – the scene today is indistinguishable from this postcard view. The former Golden Heart Inn including sign (although the inn is now a private house) is on the left as are the old cottages and shop. The remainder of the town is a similar maze of narrow streets and lanes. *(Publisher unidentified)*

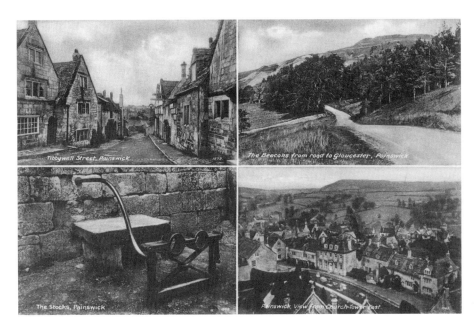

A great many of the town's old buildings owe their existence to cloth weaving and dyeing. Painswick prospered as a result, but subsequent decline meant that fewer buildings were built and older buildings were not replaced. The lack of change therefore ensured that the town remained much the same as it was in the heyday of the cloth industry, although the village has grown outwards and expanded in this century. The iron stocks are alongside the outer south wall of the church. *(H.M. Strange, The Post Office, Painswick)*

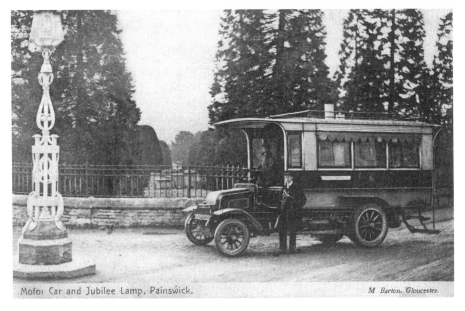

The omnibus service to Stroud. The bus is parked beside the Jubilee Lamp at the corner of Victoria Street awaiting its passengers. It followed the old stage routes and road to Stroud and picked up at the Falcon Inn, a former posting inn. The Falcon was built in the sixteenth century and has been licensed by the local justices since the seventeenth century. *(M. Barton, Gloucester)*

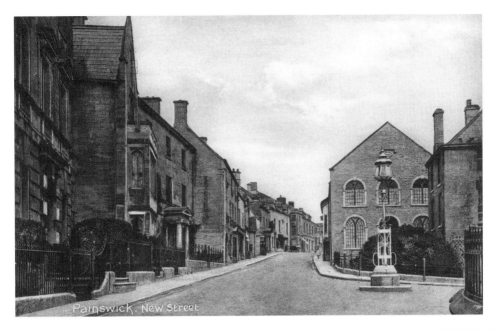

Two more views of New Street – 'new' being a relative word since New
Street was built in 1428. The ornate Jubilee Lamp that stood in the centre
of Victoria Street, no doubt caused an obstruction to the omnibus – it has
since been moved to behind the wall in the churchyard, but with a less
ornate lantern. *(Publisher unidentified)*

Joining from
Gloucester Street
the Cotswold Way
(48 miles) turns
on to New Street
to reach St Mary's
Church.

Further back along New Street on the left is the Falcon Hotel, which is
still in business today. In addition, note the GWR parcels office sign – the
railways never reached Painswick, and the nearest station was at Stroud. On
the right are the railings of St Mary's churchyard. *(Publisher unidentified)*

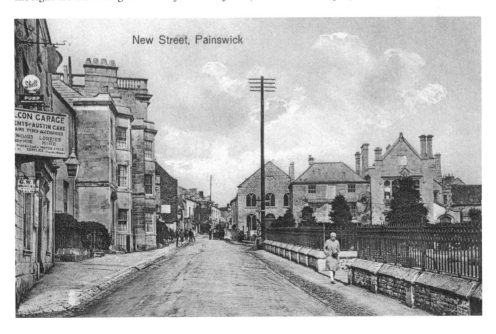

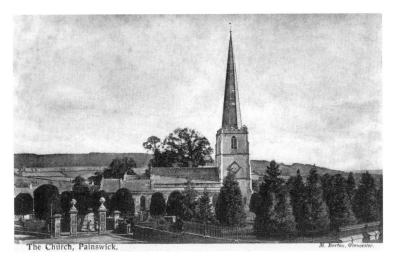

The Church, Painswick. M. Barton, Gloucester.

St Mary's Church is a grade I listed building founded in the mid-eleventh century. Parts of the existing church date from 1377 when St Peter's Chapel was built. The nave and tower were added in 1480 and the spire was erected in 1632. During the Civil War, Painswick was fought over: the church was garrisoned and defended in 1644. During the battle Royalist forces recaptured the town, and damage was caused to the church and its contents. The church also suffered damage by fire in 1883 when it was struck by lightning. The railings and iron gates in Victoria Square have disappeared since this postcard was printed. *(M. Barton, Gloucester)*

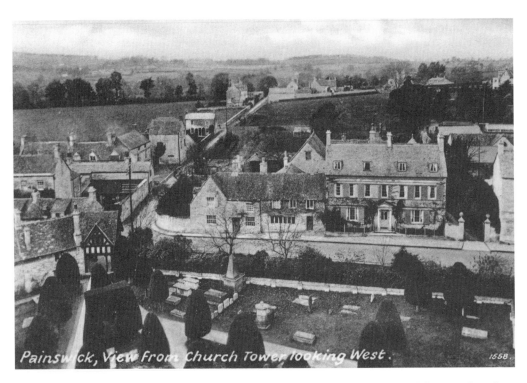

Painswick, View from Church Tower looking West. 1558.

The symmetrically sculptured yew trees, chest tombs and lychgate to New Street and the Stroud road are the most striking features of the churchyard. A local superstition is that the churchyard must never have more than ninety-nine yew trees. If the hundredth were to grow, the devil would pull it out. Estimates of the number of yews vary and the true number probably exceeds 100. *(Publisher unidentified)*

<p style="text-align:center">5</p>

Cirencester &
the Source of the Thames

'Thou shalt turn the wheels and grind many a hundred sacks of corn ere to-morrow's sun is set. And then thou shalt change thy name. No longer silvery Coln, but mighty Thames, shalt thou be called; and many a fair scene shall gladden thy sight as thou slowly passest along towards thy goal.'

(A Cotswolds Village or Country Life and Pursuits in Gloucestershire,
Joseph Arthur Gibbs, 1898)

The Cotswold Way does not enter the geographic areas covered in this chapter, but the Thames Path, another famous national route, finds its way into this part of the Cotswolds. The Thames Path follows the Thames for 184 miles from its source in the Cotswolds through London to the Thames Barrier. From source, it crosses the Fosse Way to Kemble, Ewen, Somerford Keynes, Ashton Keynes, Cricklade, Lechlade and beyond.

At Pope's Seat, Cirencester Park I have got very nicely settled in this place

Alexander Pope (1688–1744) was a friend of the 1st Earl of Bathurst and a frequent visitor to Cirencester Park. Not only a poet and satirist, Pope, together with his contemporary Stephen Switzer (1682–1745), a renowned landscape designer, helped the earl create the surrounding parkland. Pope's Seat, built in 1736 is small stone garden building. The seat for the embracing couple is far more rustic and exposed, and the same couple often appeared at many different locations superimposed on postcards of the time. *('Valentine's Series' Valentine & Sons Ltd., Dundee & London)*

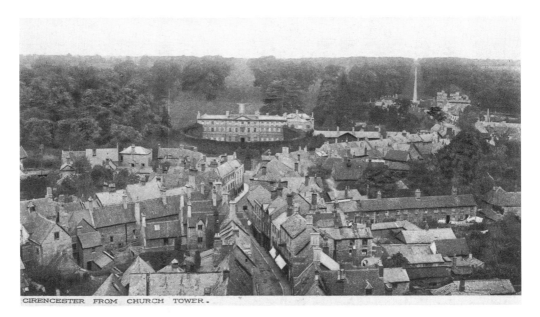

CIRENCESTER FROM CHURCH TOWER.

Considered the capital of the Cotswolds, Cirencester (or Corinium Dobunnorum as it was once known) was the second largest city in Roman Britain. It stood at the crossroads of three major routes: the Fosse Way, Akeman Street and Ermin Street. An important Roman administrative centre, by the Middle Ages it had become a large market town for the wool trade. The town is also famous as the hometown and country seat of the Bathurst (Apsley) family. The family residence Cirencester House is in the centre of this postcard, screened from the town by a large yew hedge. *(Publisher unidentified)*

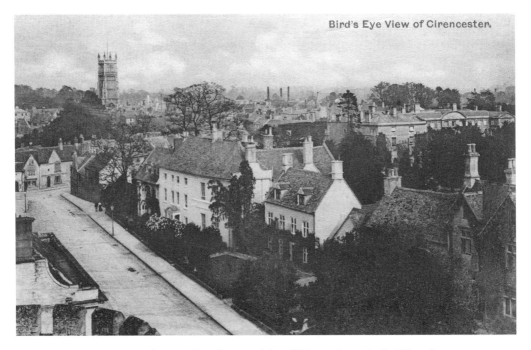

Bird's Eye View of Cirencester.

This bird's-eye view is from the crenellated tower of the Old Barracks in Cecily Hill at the entrance gates of Cirencester Park and the Broad Ride. The park is also home to the Cirencester Polo Club at Ivy Lodge, Cirencester Cricket Club, a tennis club and caravan park. *(W. Dennis. Moss & Co., Cirencester)*

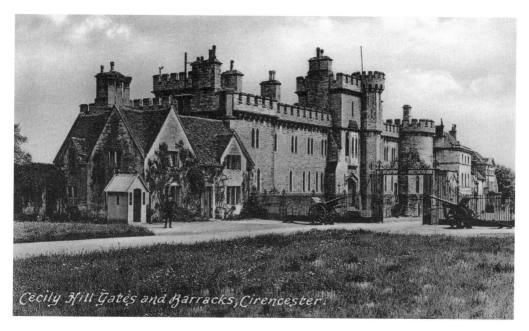

A view of Cecily Hill Gates and the Old Barracks from inside the grounds of the park. Built in 1857 as a mock castle, the building was a former armoury and a base for the 4th Battalion of the Gloucester Regiment. Used by the local Home Guard during the Second World War, it is now offices and storage for Cirencester College Business School. *(W. Dennis. Moss & Co., Cirencester)*

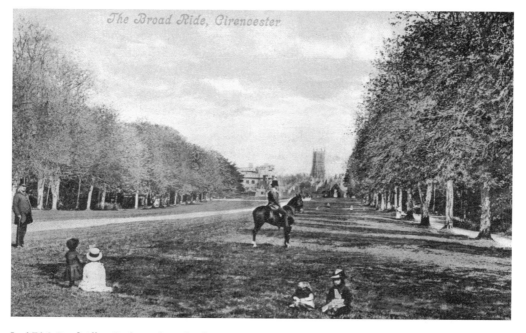

In 1716, Lord Allen Bathurst bought the estate of Sapperton to the west of Cirencester and enlarged Cirencester Park. The grounds, which included separate woodlands, were landscaped and connected with a series of open avenues. The wooded Broad Ride extends 5 miles from Cecily Hill Gates to Frampton Common, while other avenues extend in different directions focusing on ponds, Gothic garden buildings and round-points; most notably the Ten Rides which radiate from Oakley Wood. *('Valentine's Series' Valentine & Sons Ltd., Dundee & London)*

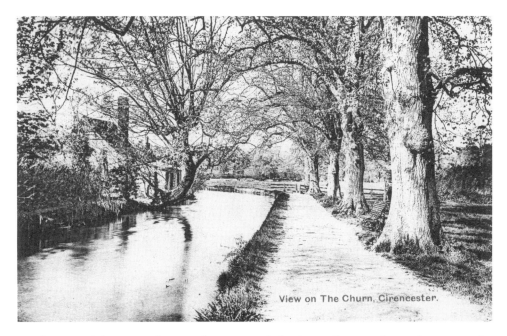

View on The Churn, Cirencester.

A tributary of the River Thames, the source of the River Churn is Seven Springs at the crossroads of the A435 and A436 south of Cheltenham. The river flows 10 miles from its source to Cirencester, accompanied for all of this stretch by the former Cheltenham and Cirencester turnpike road A435 (see page 46). The Churn enters Cirencester from the north to flow around the town to the east. *(Publisher unidentified)*

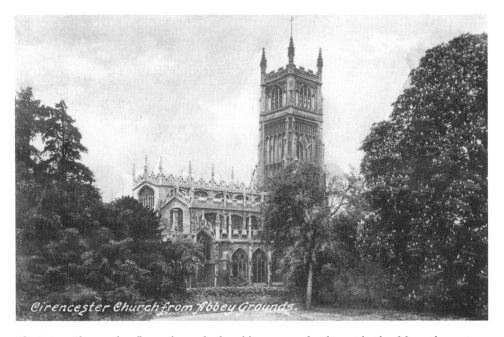

Cirencester Church from Abbey Grounds.

The River Churn also flows through the abbey grounds alongside the fifteenth-century Perpendicular Gothic parish church of St John the Baptist, the former abbey church. *(W. Dennis. Moss & Co., Cirencester)*

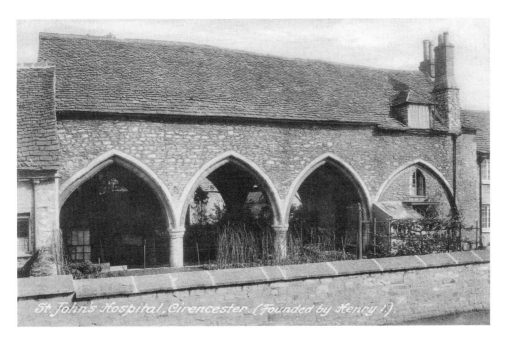

The surviving portion of St John's hospital, founded by Henry I in 1133, can still be found in the north of Cirencester at the corner of Spitalgate Lane and Gloucester Street – part of the former Roman road Ermin Street. *(W. Dennis. Moss & Co., Cirencester)*

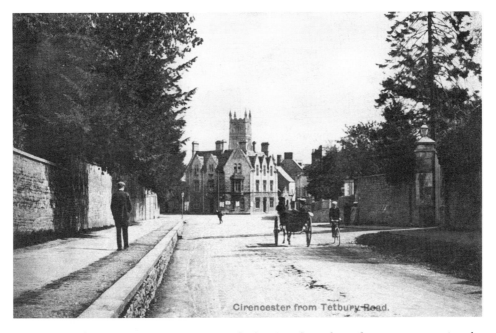

The Tetbury road is part of the Fosse Way, today's A429 that takes a diversion on entering the town from the south, but the old road enters the town from the south-west. Oakley Park and the site of the old GWR station (now just a car park although the station building still survives) are on the right, ahead is Park Lane and Sheep Street and some of the town's former posting inns. *(W. Dennis. Moss & Co., Cirencester)*

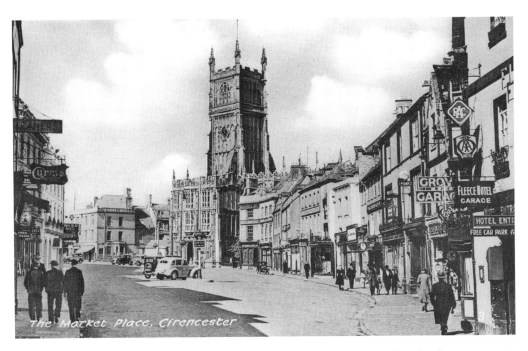

Cirencester is recorded in the Domesday Book of 1086 as a market town and to this day, an open-air street market is still held in Market Street – weekday stalls, a twice-monthly farmers' market and an antiques market. *(George Roper, Cirencester)*

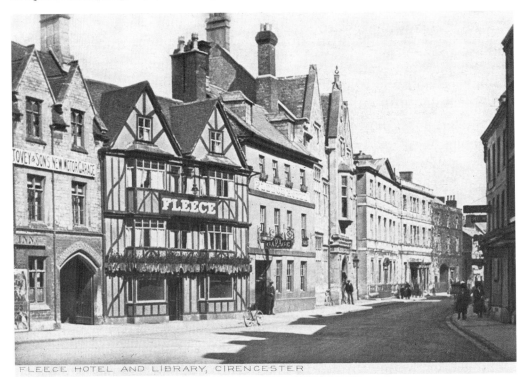

Charles II, later King of England, spent six weeks on the run from the Parliamentarians after his army's defeat at Worcester on 3 September 1651. Seeking refuge in Cirencester, tradition has it that he stayed for a night at the Fleece Inn. *(W.H. Smith & Son)*

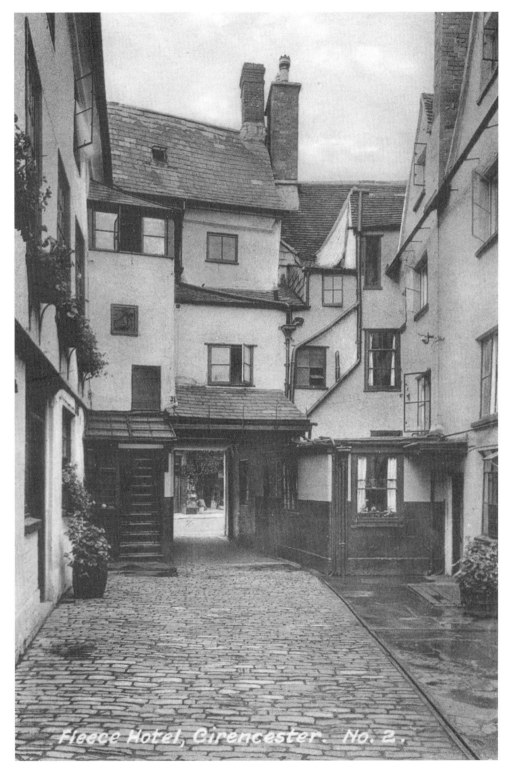

Again, the Fleece Hotel showing the rear of the hotel, coach entrance and stable yard, which is now the main entrance to the hotel. The hotel occupies three buildings dating from the mid-seventeenth, eighteenth and nineteenth centuries respectively. *(W. Dennis. Moss & Co., Cirencester)*

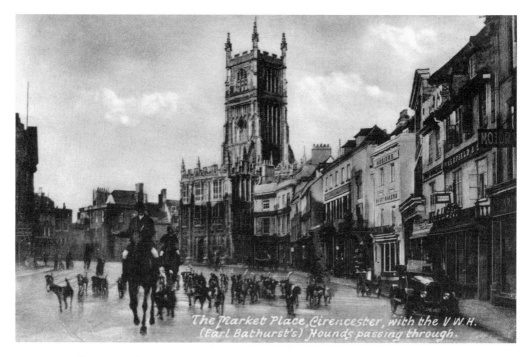

A scene surely never to be seen again, the Vale of the White Horse (VWH) Earl Bathurst's Hounds passing through the Market Place. The VWH hunt was founded in 1830 and covered a huge area of country, though subsequently it was divided between Cricklade and Cirencester. The 7th Earl Lord Apsley took over Mastership of the VWH (Cirencester) Country and the (Lord Bathurst's) Hounds from his father, and remained in change until his death in 1943. The 8th Earl became master of the hunt from 1949 until 1966. *(W. Dennis. Moss & Co., Cirencester)*

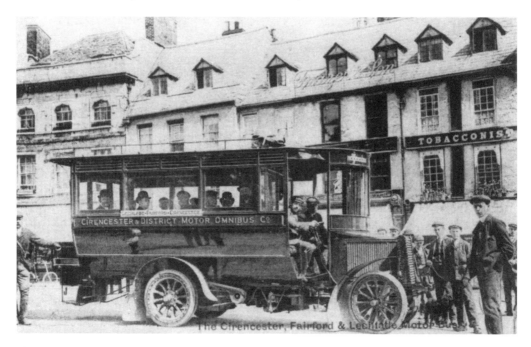

The Cirencester, Fairford & Lechlade motor bus collecting passengers beside the Corn Hall opposite the parish church in the Market Place. The modern no. 877 bus operates a similar service. *(Publisher unidentified)*

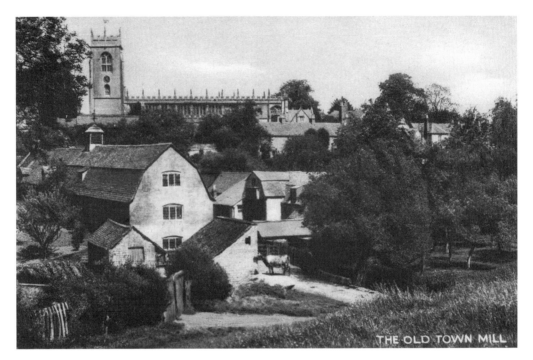

10 miles north-east of Cirencester is the source of the 18-mile long River Leach, a tributary of the Thames. The Leach rises on the Cotswolds dip slope and immediately flows into the small mill town of Northleach. This stretch of the Leach, which only appears as a stream after sufficient rain, feeds the millpond of the Old Town Mill below the Church of St Peter and St Paul in Mill View. When the river emerges fully, it flows in a south-easterly direction through a charming Cotswold valley, and through the town of Eastleach to join the Thames next to St John's Bridge and the Trout Inn. *(Publisher unidentified)*

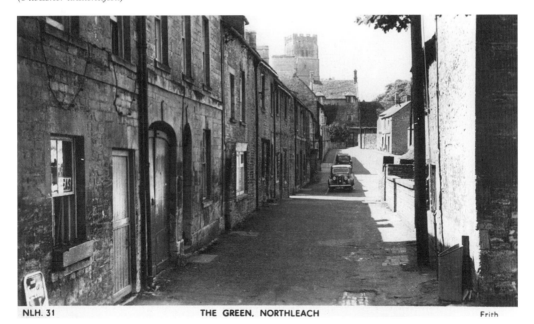

The Green at Northleach looking from The Peep, a small side-street that leads to the Market Place at the centre of the town. In the background we see the Church of St Peter and St Paul. *(Publisher unidentified)*

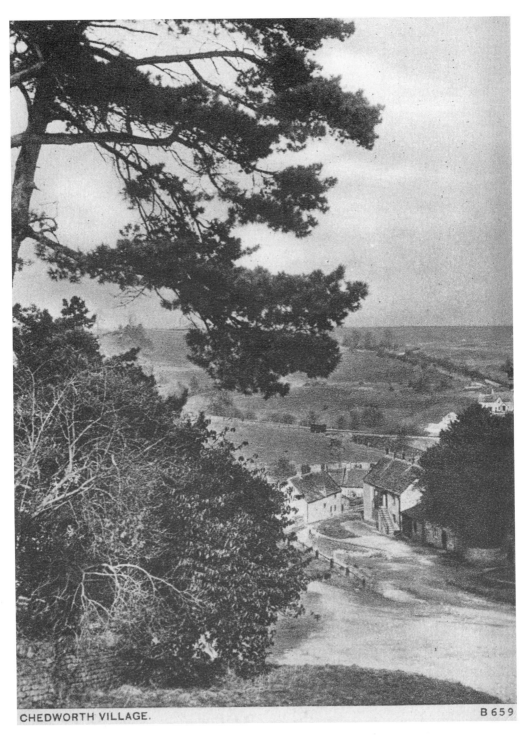

CHEDWORTH VILLAGE. B 659

About 4 miles to the south-west of Northleach is another Cotswold valley where a small stream flows through Chedworth. Here we look down from the top of Queen Street towards the charming and homely Seven Tuns pub, which has a sign over the door reading 'Circa 1610'. At the foot of the hill and nearby are village houses and a waterwheel. The stream joins the River Coln as it flows under the Fosse Way at Fosse Bridge. *(The 'Borough' Series)*

Lord Eldon's gamekeeper accidentally discovered Chedworth Roman Villa in 1864, when he unearthed pieces of tessera and pottery in Chedworth Woods. A museum was built to house the excavated finds from the fourth-century Romano-British villa. Excavated mosaic floors are covered and protected by wooden roofed structures, and since 1924 the National Trust has looked after the site. The Fosse Way passes 2 miles to the south-east of Chedworth Villa and there are more Roman villas nearby, along the banks of the River Coln. *(N. Dennis Moss, Cirencester)*

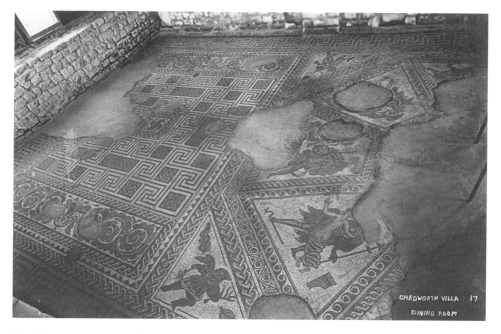

The dining room mosaic between the west and south ranges of the villa are the finest excavated at Chedworth. *(Pitcher Gloucester)*

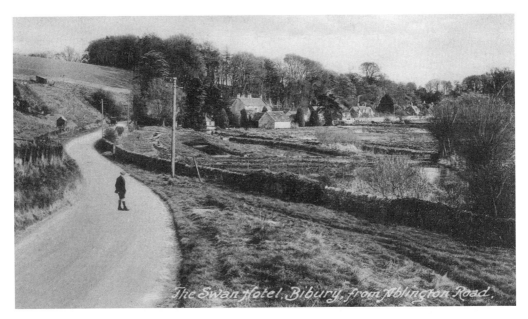

Ablington Road approaching the bridge and Swan Hotel at Bibury on the River Coln. Watercress ponds once occupied the water meadow on the right, but in 1902 they became a trout farm. The trout farm has become a popular attraction for the coachloads of visitors who are allowed to walk around the ponds to witness the feeding of the fish. There is also a souvenir shop and fish shop which sells local produce and, naturally enough, packaged brown and rainbow trout. *(Publisher unidentified)*

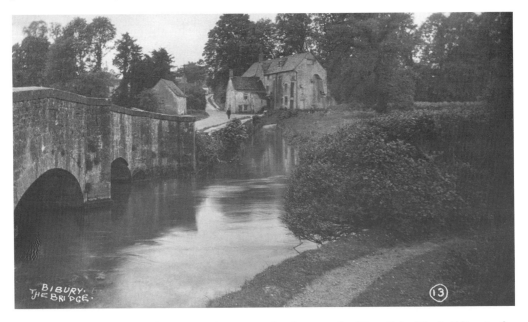

The bridge at Bibury takes the B4425 Cirencester Road across the River Coln. The building in the background is the predominantly eighteenth-century cloth and fulling mill at Arlington. Parts of the mill are earlier but the building chiefly dates back to the seventeenth century, recorded in 1608 as a mill. Corn was ground during the 1920s and the mill was disused by 1934. Bibury is actually two villages divided by the River Coln: Arlington to the west and Bibury to the east. *('Cambria Series' W. A. Call, The County Series, Monmouth)*

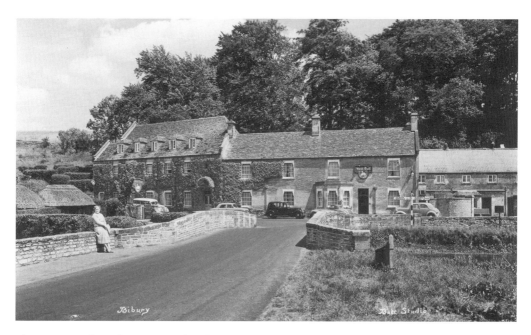

The Swan Hotel at Bibury is a grade II listed, predominantly mid-eighteenth-century former coaching inn, modified and extended during the 1930s for the benefit of the touring motorist visitor. Parked alongside the frontage are the guests' cars. The Swan was known to have been an inn in the seventeenth century, and parts of the building might have been converted from early seventeenth-century cottages. *(Publisher unidentified)*

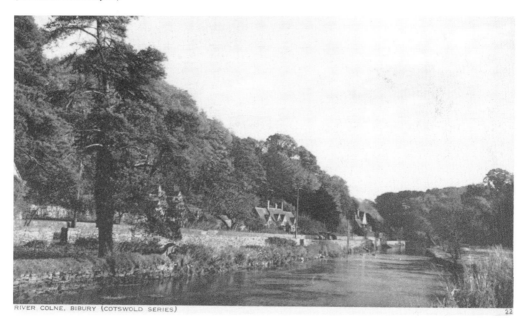

The view downstream from the bridge along the Burford road, towards Church Street. Many summer visitors to Bibury use this stretch of road for parking their cars – a far cry from the one or two vehicles seen in these postcard views. However, the bustle of visitors has ensured that the village post office and grocery store along this road has stayed in business, unlike many other small English villages that have lost their amenities. *(Photochrom Co. Ltd., London & Tunbridge Wells)*

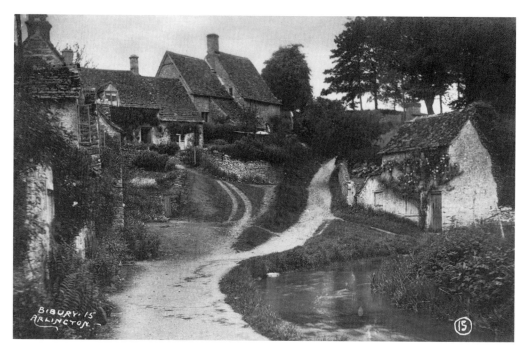

Originally the location of a monastic wool store, the buildings in Arlington Row were converted to weavers' cottages in the seventeenth century, and they are perhaps some of the most photographed buildings in the Cotswolds. Woven cloth was gathered and fulled (scoured and beaten mechanically with the addition of chemicals to cleanse the fabric) and dried on frames beside Arlington Mill. Finished folded cloth then found its way by road to the nearby cloth towns for sale. *(Publisher unidentified)*

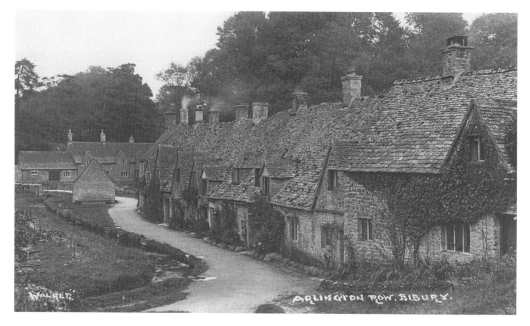

Another view of Arlington Row. The small stream on the left flows into the River Coln and the row of buildings in the distance are on the opposite bank of the Coln and alongside the Burford Road which leads out of the village (see top opposite). *(Wallet)*

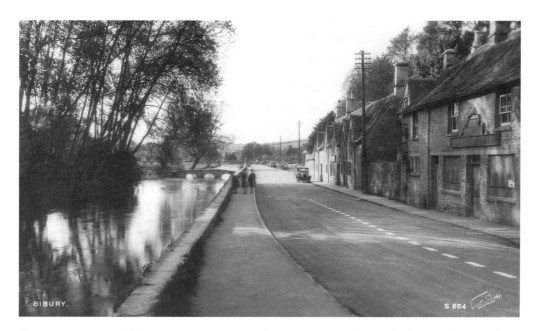

The small stream which runs past Arlington Row emerges on the bank of the Coln, left of the three-arched bridge. After crossing the Coln further upstream by the Swan Hotel, the Cirencester and Burford road runs parallel to the river until this spot at the junction of Church Street. From here, the river diverges to meander for 5 miles in a south-easterly direction to Fairford. The exteriors of the buildings on the right have remained unchanged, converted into a gallery, post office and arts and crafts shop. The Arts and Crafts Movement features prominently in the village – William Morris visited Bibury and said that it was 'the most beautiful village in England'. *(Walter Scott, Bradford)*

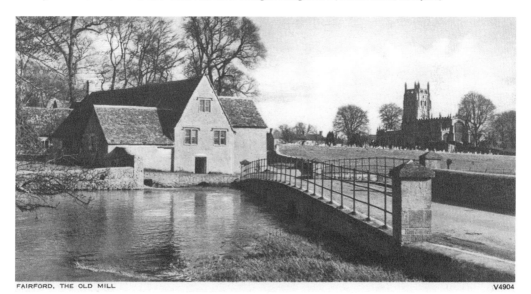

The River Coln at Fairford from the grade II listed late eighteenth-century bridge and old mill to the east of the town. Beyond the meadow is the tower of St Mary's, Fairford's Anglican parish church, famed for its medieval stained-glass windows. The base of the church tower dates from the early fifteenth century and the remainder of the church dates from the late fifteenth to the early sixteenth centuries (with nineteenth-century restoration). The church remains a fine example of the Perpendicular style. *(Publisher unidentified)*

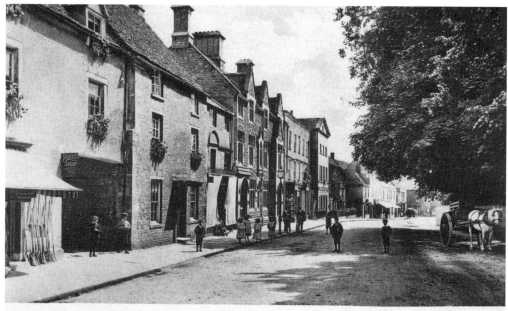

High Street, Fairford.

Fairford High Street's eighteenth-century buildings leading away to the Market Place are today a gallery, opticians, pharmacy and bank. *(Publisher unidentified)*

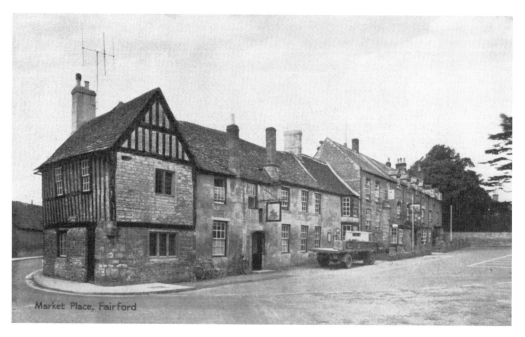

Market Place, Fairford

From the Middle Ages, Fairford developed as a Cotswold market town, although today it is more famously identified with the RAF base to the south of the town. Fairford was granted a charter to hold a market in 1135. The half-timbered building on the left is the post office and beyond it is the Bull Hotel in the Market Place. The Bull Hotel dates back to the late sixteenth century or possibly earlier when it was reputed to have been an ecclesiastical building. From the sixteenth century, it served as a guildhall and by the seventeenth century it was an established posting inn. *(T.V.A.P., Oxford, Series)*

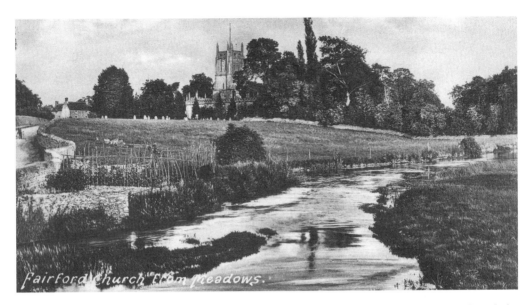

Returning to the River Coln at Mill Lane Bridge and the water meadow below St Mary's churchyard, the surrounding meadows here are prone to flooding, and the town has witnessed severe floods in recent times. The River Coln, on leaving Fairford, passes a series of lakes to the south-east. In common with many natural areas of the Cotswolds, the future of the lakes has become an issue among opposing interests. Discord exists between potential developers who have submitted planning proposals for housing developments and their opponents who wish to preserve the peaceful, rural character of the area. (*W. Dennis. Moss & Co., Cirencester*)

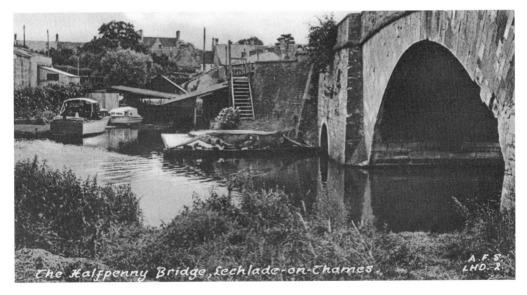

Beyond Fairford, the River Coln flows for another 4 miles to meet the Thames at Inglesham, a short distance upstream of Halfpenny Bridge at Lechlade-on-Thames. The now-derelict Thames & Severn Canal also once joined the river at the confluence. The canal entered the river by a lock manned from a familiar lengthman's roundhouse cottage, one of many such distinctive buildings on this canal. Halfpenny Bridge, built by James Hollingworth in 1792, acquired its name because of the halfpenny tolls charged to people crossing on foot. The toll was collected at the small adjoining tollhouse on the north side of the bridge. The road bridge carries today's A361. (*F. Frith & Co. Ltd., Reigate*)

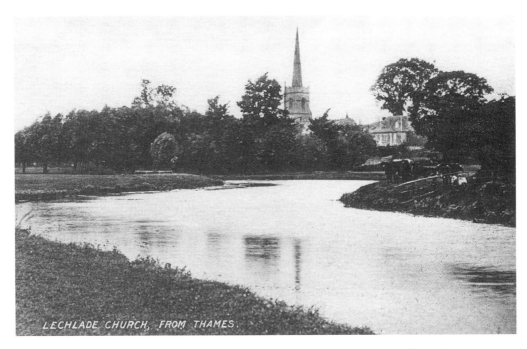

LECHLADE CHURCH, FROM THAMES.

The water meadows below Halfpenny Bridge and the spire of the Perpendicular style St Lawrence church, built in 1476. The stretch of the Thames at Lechlade is the furthest point that a boat can navigate westwards into the Cotswolds. The source of the Thames lies well within the Cotswolds at Trewsbury Mead south-west of Cirencester. Most of the time there is little more than a trickle and sometimes the flow dries up completely within the first half mile before Thames Head Bridge and the Fosse Way. At Cricklade the Thames meets another Cotswold river, the Churn from Cirencester, and another Roman road, Ermin Street. *(Country Series Varsity Oxford)*

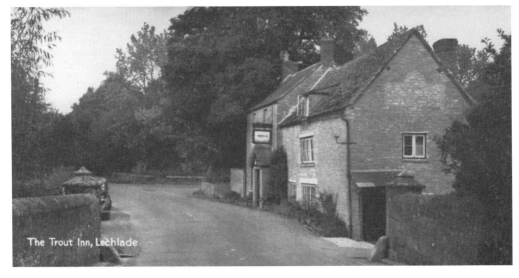

The Trout Inn, Lechlade

The Trout Inn at St John's Lock, downstream of Lechlade-on-Thames, is the uppermost lock on the navigable Thames. The pub is an ideal place to moor a boat and spend time relaxing, eating and drinking. Unspoilt and a perfect example of a Cotswolds hostelry, the only discernable difference from the outside between this postcard view and the present day is that the pub sign, which shows a trout swimming away from the pub door, is today reversed. *(Publisher unidentified)*

6

The South Cotswolds & Bath

'Every morning now brought its regular duties – shops were to be visited; some new part of the town to be looked at; and the pump-room to be attended, where they paraded up and down for an hour, looking at everybody and speaking to no one. The wish of a numerous acquaintance in Bath was still uppermost with Mrs. Allen, and she repeated it after every fresh proof, which every morning brought, of her knowing nobody at all.'

(*Northanger Abbey*, Jane Austen, 1803)

The Cotswold Way heads south and overlooks the Severn Vale to the west from Coaley Peak and Frocester Hill. For the remainder of its course it follows a route along the Cotswold Edge through Dursley, past the Tyndale Monument, Wotton-under-Edge and passes the Somerset Monument (80½ miles). After crossing the M4 (88 miles) it follows the high ground of the Cotswolds for another 16 miles to arrive at the city of Bath (104 miles) and its final destination.

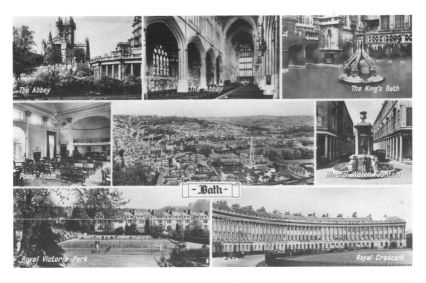

The elegant city of Bath lies at the southern extremity of the Cotswolds AONB. Rising above the city from the Lower Avon Valley, the hills extend in a north-easterly direction almost as far as Stratford-upon-Avon in Warwickshire and another River Avon.
(*English Series, Photo-Precision Ltd., St. Albans*)

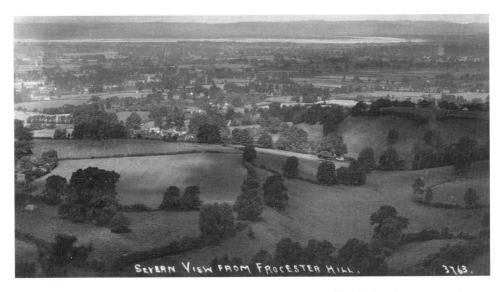

SEVERN VIEW FROM FROCESTER HILL. 3763.

Leaving Pen Hill
(60 miles) the
Cotswold Way
takes a route
over the wooded
edge to the top of
Frocester Hill
(62 miles).

The Severn Estuary viewed from Frocester Hill. The M5 takes up part of
this scene crossing from left to right just below the lower slopes. The River
Severn, its estuary and the M5 serve to mark the natural and man-made
western boundary to the Cotswolds. In the distance are the Forest of Dean,
Herefordshire's Wye Valley and the hills of South Wales.
(*Publisher unidentified*)

The Dursley–Stroud turnpike road today is the B4066. Seen here entering
from the south of the village of Uley where it crosses Fop Road, the tollhouse
has gone but the scene is still recognisable. The village was a stagecoach
stop and a small manufacturing base for a local blue cloth. Decline of the
wool trade eventually brought a total loss of industry, and today the village
is a commuter base for Stroud, Dursley and the M5. (*Publisher unidentified*)

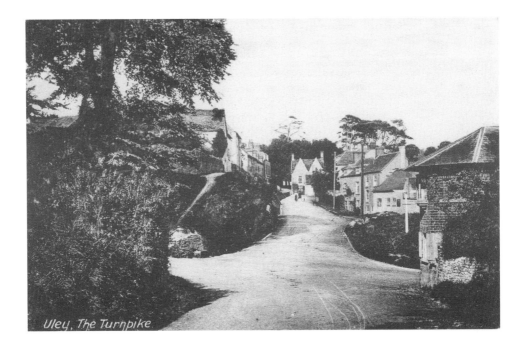

Uley, The Turnpike.

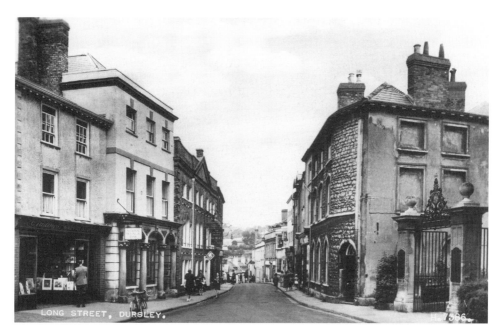

The manufacturing town of Dursley and Long Street heading towards the north-east. On the right is the gate of St James' Church and the hotel on the left is the Old Bell Hotel or nowadays just the Bell Hotel since the letters that spell 'Old' have been removed from the sign above the doorway. *(Publisher unidentified)*

Dursley Market House from Silver Street. The market hall stands in the centre of the town where two other streets join: Long Street and Parsonage Street. The Market House was built in 1738 and stands on pillared arches which support the Town Hall on the upper storey. The carving in the south wall is the Estcourt coat of arms, the local family who funded the building. The statue in the alcove is of Queen Anne. *(Publisher unidentified)*

From Frocester Hill, the Way passes Hetty Pegler's Tump long barrow and Uley Bury hill fort (64 miles). Above the village of Uley the Way descends into the Dursley Valley and then enters the town by Long Street (66 miles).

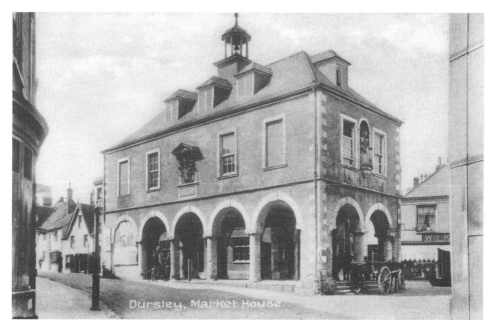

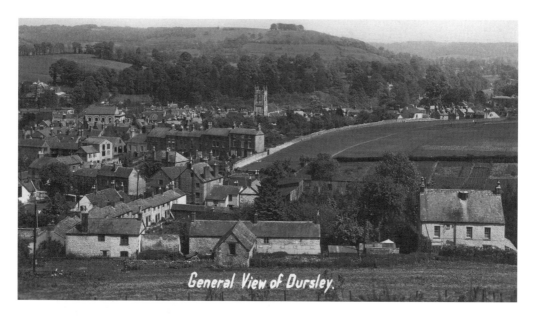

General View of Dursley.

Leaving Dursley, the Cotswold Way climbs to Stinchcombe Hill and circumnavigates a golf course (68 miles). Above the village of Stinchcombe to the west, the way then heads south to Nibley Knoll and the Tyndale Monument (71 miles).

A view of Dursley with the tower of St James' Church prominent in the centre. To the left is Dursley Methodist Church in May Lane and in the distance is Small Pox Hill or Downham Hill, and further still Uley and Owlpen. *(Publisher unidentified)*

St Cyr's Church, Stinchcombe, with its tower (which dates from 1630) and the former village school in Wick Lane. *(Publisher unidentified)*

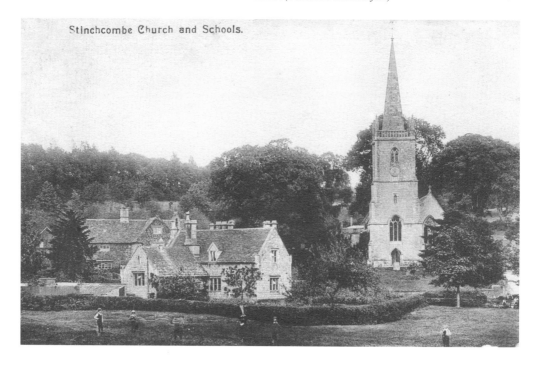

Stinchcombe Church and Schools.

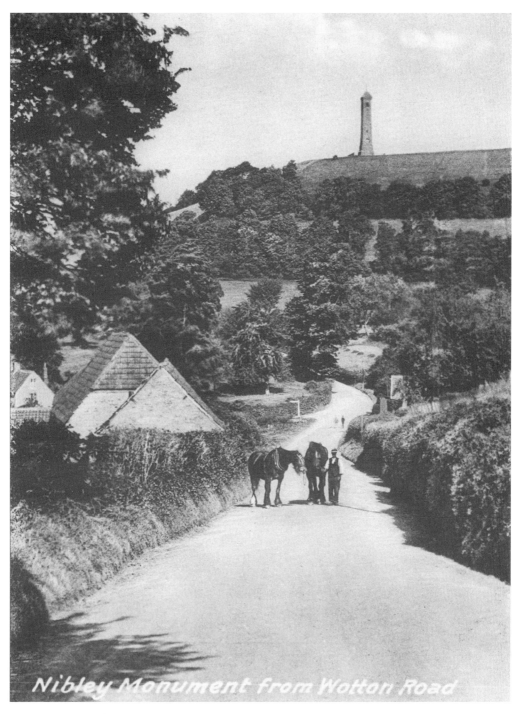

Nibley Monument from Wotton Road

At a little over a 100ft tall, Nibley Tower was erected in 1866 as a monument to William Tyndale (1494–1536), the translator of the New Testament into English. A key to the monument can be collected from the village shop and post office in Barrs Lane, North Nibley, for a deposit and an admission charge. A spiral staircase leads to the viewing platform that commands views of the Severn Estuary. The Wotton-under-Edge road passes through the centre of North Nibley beside the Black Horse Inn at the corner with Barrs Lane. *(Publisher unidentified)*

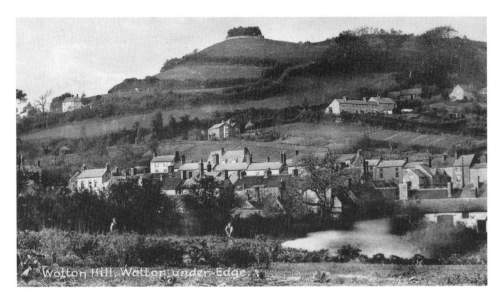

From Wotton Hill the Cotswold Way passes through the centre of Wotton-under-Edge (73½ miles); it enters by Bradley Street, and leaves the town by Valley Road. It then continues in a southerly direction through Wortley, Alderley, Little Sodbury and Old Sodbury to reach the M4 at Tormarton (88 miles).

Looking up to Wotton Hill, the houses in the middle distance are along Gloucester Street and further up on the Old London Road. Above them is the group of trees planted to commemorate the Battle of Waterloo. The fields in the front of the view are now a housing estate. *(Publisher unidentified)*

Similarly, this semi-rural scene has also changed, as there is a great deal more housing obstructing the view of Wotton from Wortley Road. St Mary the Virgin Church is still a prominent landmark, as is the Tabernacle built in 1850, visible in the top left-hand corner. The road in the centre of the picture is Dyers Brook. *(Publisher unidentified)*

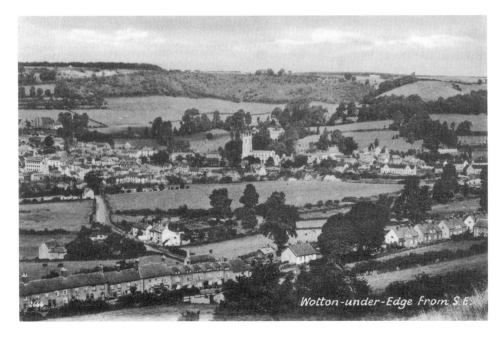

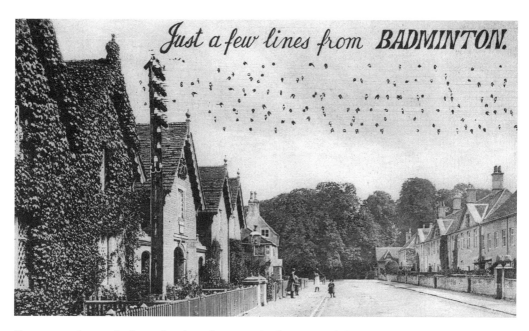

Even a superimposed telegraph pole and roosting birds on wires fail to distract from the charm of this Cotswold village scene. About 5 miles east of Chipping Sodbury and the Cotswold Edge is the quiet rural village of Great Badminton and its neighbouring hamlet, Little Badminton. Badminton is famous for Badminton House, the family seat of the Duke of Beaufort, and equally famous for the horse trials and the racquet game named after it. The building on the left was at one time the post office that has since relocated a few doors along the High Street. In the distance is the entrance to Badminton House. *(Publisher unidentified)*

Great Badminton High Street, again this time looking west at the crossroads between Kennel Drive and The Limes which joins onto Station Road. The station on the main Bristol & South Wales line closed in 1968 as a consequence of the declining number of people using the railway. *(Wilkinson & Co., Trowbridge)*

Chipping Steps, Tetbury. As we have seen earlier, 'chipping' means market, therefore chipping steps simply mean the market steps, which today lead to a car park, though it was once part of the market square of the town. The Mop Fair was also held on the steps: this was the annual event where farmers and other prospective employers could hire farm hands and labourers. The steps themselves date back to medieval times and the buildings lining them date from the seventeenth and eighteenth centuries. *(Publisher unidentified)*

Silver Street, Tetbury, from the Green. In the distance is the Crown Inn in Gumstool Hill, the start line of the annual Whitsun bank holiday woolsack race. The town's coat of arms features two dolphins, but the origin of this symbolism is uncertain. Suggested explanations are that the dolphins were copies of a mosaic in a nearby Roman villa, but more probably originated from a local family crest. What is known for sure is that the town has used the arms from the late seventeenth century. *(A. Tugwell, Tetbury, posted 1907)*

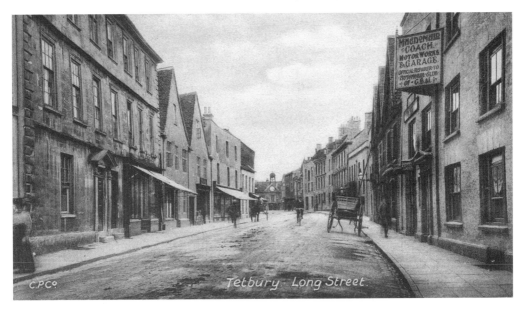

Two views from opposite ends of Long Street, Tetbury, with the seventeenth-century Town Hall in the distance. The Market Hall was built in 1655 and is still used for its original purpose as a covered market. Many of Tetbury's shops and businesses have changed over time as one might expect – the building on the left now deals in antiques, while the building on the right, a former garage (since demolished), is now a yard that also belongs to another antiques business. *(The Cotswold Publishing Co., Charfield: Glos)*

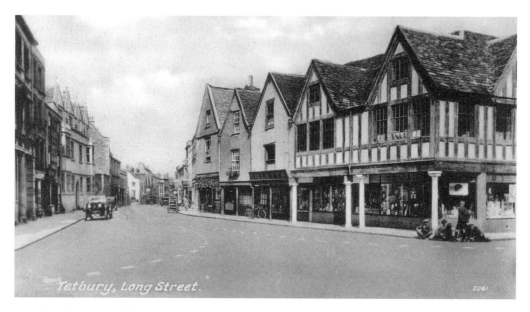

Immediately recognisable to Tetbury residents and visitors is Long Street. Looking away from the Town Hall, the buildings are principally seventeenth- and eighteenth-century, and echo Tetbury's former prosperity as a Cotswold wool town. Indicative of a time of wealth and prosperity is the building with the parked car in front of it, which is now the Close Hotel, built in 1535 for John Steede, a Yeoman. The Close Hotel and Restaurant holds the enviable reputation of being one of the finest sixteenth-century townhouses in the Cotswolds. The house, one of Tetbury's finest buildings, was also once the residence of a wealthy wool merchant and was converted to use as a hotel in 1974. *(Publisher unidentified)*

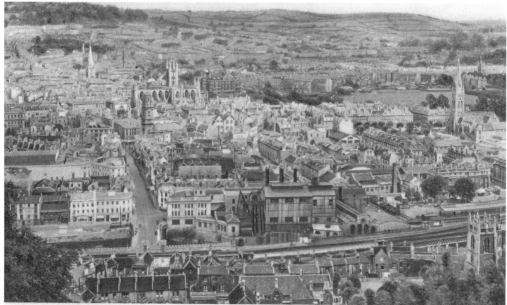

BATH FROM BEECHEN CLIFF

In the centre of this picture is Bath Abbey, while the two churches on the right are (bottom right) St Mark's and (top right) St John's. The city is on the southern edge of the Cotswolds, historically and geographically part of Somerset. Bath was founded by the Romans as Aquae Sulis but really became fashionable as a Georgian Spa and inland resort. *(E.A. Sweetman & Son, Ltd., Tunbridge Wells)*

THE LAKE, ROYAL VICTORIA PARK, BATH,

Princess Victoria opened the Royal Victoria Park in 1830 before she was made queen. It was the first park dedicated to her name. In 1921, Bath Corporation took over the upkeep of the park from private ownership, and since 2007 Bath and North-East Somerset unitary authority have undertaken a program of restoration to bring the park back to its former grandeur. *(Max Ettlinger & Co., Ltd.)*

The bridge and the connecting ponds are home to ducks and swans. There is a botanical garden, bowling green and play area, and the park hosts a variety of events that include the Bath flower show, concerts and hot air balloon rallies. *(Excel Series)*

After crossing the M4, the Cotswold Way passes through Dyrham and Cold Aston before approaching the outskirts of Bath at Lansdown Hill (100 miles). For the final stretch of 2 miles through the city of Bath, the Cotswold Way crosses Victoria Park (103½ miles) and the Royal Crescent.

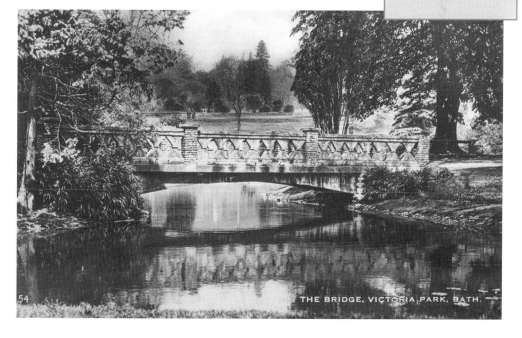

THE BRIDGE, VICTORIA PARK, BATH.

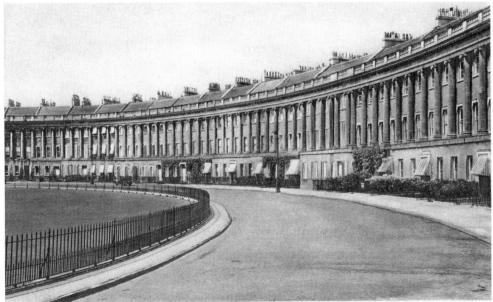

ROYAL CRESCENT, BATH 8185

The Royal Crescent
(103½ miles) and the
entrance to the abbey
mark the end of the
Cotswold Way.

The Royal Crescent, built during the third quarter of the eighteenth century, is one of the finest examples of Georgian architecture in England. The architect John Wood the Younger designed the curved front façade to thirty separate houses and each owner of a house contracted their own architect to design the building behind it. No. 1 Royal Crescent is the Bath Preservation Trust Museum, nos 15 and 16 comprise the Royal Crescent Hotel, and the remaining properties are privately owned. *(E.A. Sweetman & Son, Ltd., Tunbridge Wells)*

The Abbey Church of St Peter and St Paul was part of a Benedictine monastery founded in the seventh century. Bath Abbey Church dates predominantly from the twelfth century. Restored and added to over the centuries, the church underwent major restoration by George Gilbert Scott in 1860. *('Valentine's Series' Valentine & Sons Ltd., Dundee & London)*

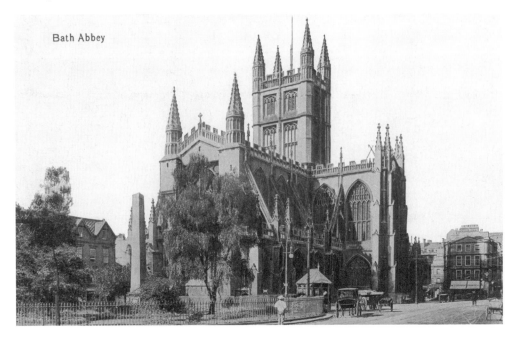

Bath Abbey

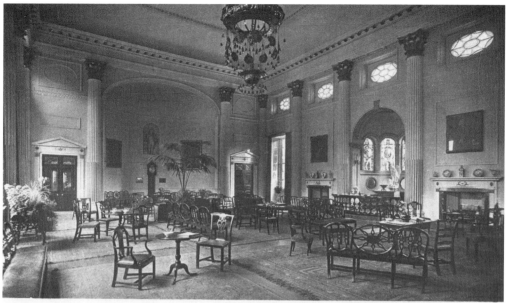

BATH. THE GRAND PUMP ROOM.

The Grand Pump Room, the perfect location for afternoon tea, opened in 1795 and it has attracted visitors ever since, to partake of refreshment and drink the mineral waters, accompanied by classical music from either a pianist or the Pump Room Trio. The actual Roman baths are below street level and include the sacred spring (the source of the heated waters), Roman temple, spring overflow, changing rooms, sauna, heated rooms, plunge pool and Great Bath. *(Visitors Enquiry Bureau, Bath)*

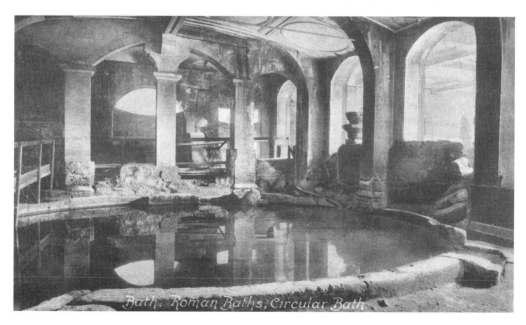

Bath, Roman Baths, Circular Bath

The Roman circular bath, or frigidarium, was used for a cold plunge after a long soak in the warm waters of the thermal baths. Unfortunately, public bathing in the waters at the Roman Bath ended in 1979, owing to the potential health risks from lead piping and bacteria. However, the experience of a natural spa has not been lost to the city and the Thermae Bath Spa in nearby Bath Street offers sessions in its thermal waters. *(F. Frith & Co. Ltd., Reigate)*

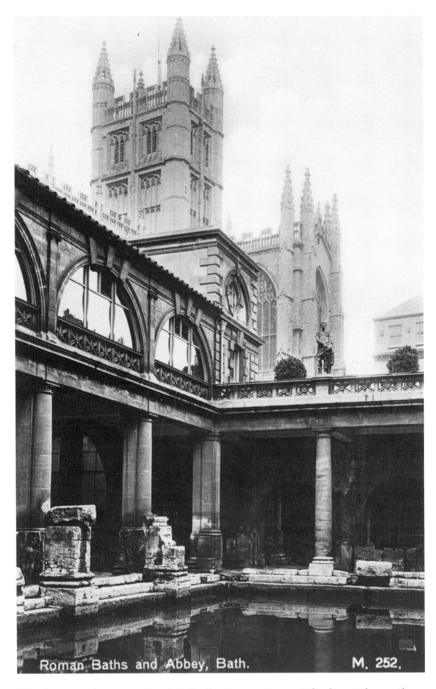

Roman Baths and Abbey, Bath. M. 252.

The elegant and ancient city of Bath, the Roman Aquae Sulis, lies at the southern edge of the Cotswolds, and its centrepiece is the Roman Great Bath overlooked by the medieval Bath Abbey. Once roofed with a vaulted ceiling, this lead-lined pool is fed directly from the sacred hot mineral spring. *(Publisher unidentified)*

Bath Abbey is an ideal location to end, or start, a long-distance walk through the Cotswolds. At 104 miles in total, the Cotswold Way offers pretty honey-coloured buildings, tightly clustered on steep valley sides in villages and towns, and some of the most spectacular scenery in rural England.